Cartooning

FOR THE BEGINNER

CHRISTOPHER HART

WATSON-GUPTILL PUBLICATIONS/NEW YORK

For my grandfather, Abe Shorin,
a wonderful grandparent,
a wise and gentle teacher.

I'd like to thank everyone at Watson-Guptill Publications for being who you are—just the best darn group of publishing guys an author's ever had the privilege to work with, that's all: Glenn Heffernan, Harriet Pierce, Candace Raney, Bob Fillie (when he can make it), Ellen Greene (for making sure Bob can make it), and Hector Campbell.

Special thanks to my daughters: Isabella for the penguin, and Francesca for her honest opinions—although it's okay to humor your dad once in a while. Sheesh!

Senior Editor: Candace Raney
Project Editor: Sarah Fass
Designer: Bob Fillie, Graphiti Design, Inc.
Production Manager: Hector Campbell

Text and illustrations copyright © 2000 by Christopher Hart

First published in 2000 by Watson-Guptill Publications, Crown Publishing Group, a division of Random House Inc., New York
www.crownpublishing.com
www.watsonguptill.com

Library of Congress Card Number: 00–101905
ISBN 0-8230-0586-0

Manufactured in China

First printing, 2000

10 11 12 13 14 / 10 09

4

Contents

Introduction

Welcome! If you've ever wanted to draw cartoons, or if you've ever dreamed of being a cartoonist, then you have just lucked out *big-time.* This is the blueprint, the road map, the mother lode.

This book is for the aspiring cartoonist with little or no prior experience, as well as for those who find themselves stuck in an artistic rut. All the basics will be covered in step-by-step illustrations. It is my belief that you cannot read yourself into drawing better, so every page in this book is packed with visual examples.

You may be starting off as a beginner, but if you follow my instructions and practice the techniques I show you, you won't end up as one! By the middle of this book, you'll be producing intermediate drawings, and by the end, you'll be tackling some exciting, cutting edge concepts in cartooning.

Cartooning for the Beginner features many styles. You'll learn traditional cartooning, how to draw weird and edgy cartoons that are on the vanguard of today's animated TV shows, and even how to draw the realistic-style cartoon characters used in blockbuster animated movies.

In addition to chapters on the basics, like how to draw cartoon heads and bodies, I've included many sections on topics you won't find anywhere else. For example, there's a chapter on the ten most common mistakes made by beginning cartoonists and how to avoid them, as well as a chapter covering

the basics of film animation. The book ends with a section of questions and answers for those considering a career in cartooning.

Since your author is not a two-dimensional cartoon character, I thought I'd send a little friend to help demonstrate the keys to cartooning to you. He's a little penguin who has been making himself quite comfortable in my imagination lately. But I'll let him introduce himself . . .

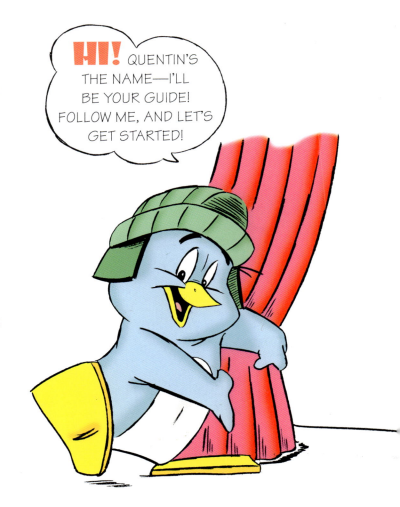

HI! QUENTIN'S THE NAME—I'LL BE YOUR GUIDE! FOLLOW ME, AND LET'S GET STARTED!

DRAWING THE
Cartoon Head

We'll begin with the head because it's the part of the body that's the most fun to draw. When you start with the head, you get to create a character right away. Then we can start to work on other things, like facial expressions, the body, motion, and backgrounds.

THINK OF THE HEAD AS A THREE-DIMENSIONAL GLOBE!

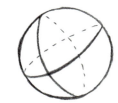

When drawing the head, remember to think of it as a three-dimensional object with roundness and depth. Just because you're drawing on flat paper doesn't mean your drawing has to look flat!

BUT... AS YOU CAN SEE, THE HEAD ISN'T A PERFECT CIRCLE—WE'LL HAVE TO MAKE SOME ADJUSTMENTS.

Quentin's right. The head is a bit more complex than a simple circle or a globe—but not *that* much more complex. We'll make it simple and easy to do. Come on, let's keep going!

STRETCHING THE GLOBE TO FIND THE CORRECT HEAD SHAPE

Everything in cartoons is rubbery, including the head. So, let's start with our basic globe, and *stretch* it into the best basic shape for the basic cartoon head. Here we go!

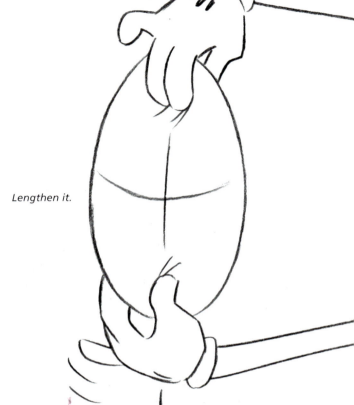

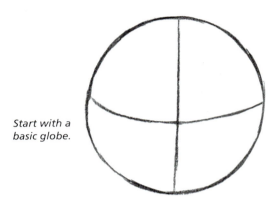

Start with a basic globe.

Lengthen it.

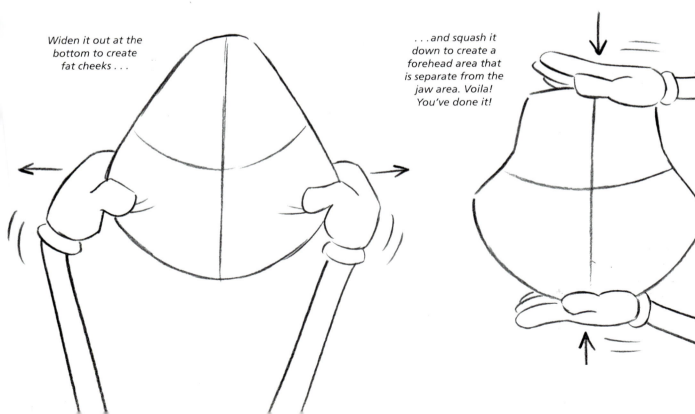

Widen it out at the bottom to create fat cheeks . . .

. . . and squash it down to create a forehead area that is separate from the jaw area. Voila! You've done it!

CREATING A FACE FROM THE BASIC HEAD SHAPE

Now that we've drawn the outside of
the head, let's put some features on it.

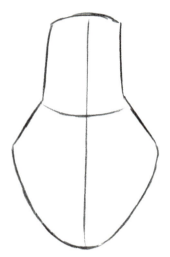

*First, add some guidelines,
as I have done here.*

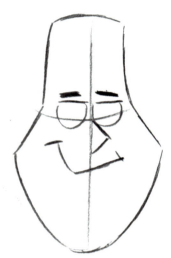

*Place the bridge of the nose at the point
where the guidelines intersect. Place the
eyes, or in this case, the glasses, evenly
spaced on either side of the vertical
guideline. Good. Let's keep going.*

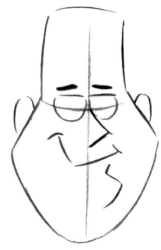

*Now we fill in the ears, at approximately
the height of the eyes, and add a lower lip
and chin to the mouth area.*

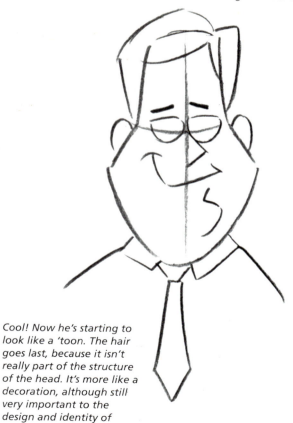

*Cool! Now he's starting to
look like a 'toon. The hair
goes last, because it isn't
really part of the structure
of the head. It's more like a
decoration, although still
very important to the
design and identity of
the character.*

*Now erase your initial
guidelines (or retrace your
last drawing, being sure to
leave out the guidelines),
and add the details, such as
forehead wrinkles, streaks
of hair, clothes, etc. Not too
shabby, partner!*

THE CHEEK PROTRUSION

Most cartoon characters have protruding cheeks. Look at these examples and notice how all of the cheeks protrude.

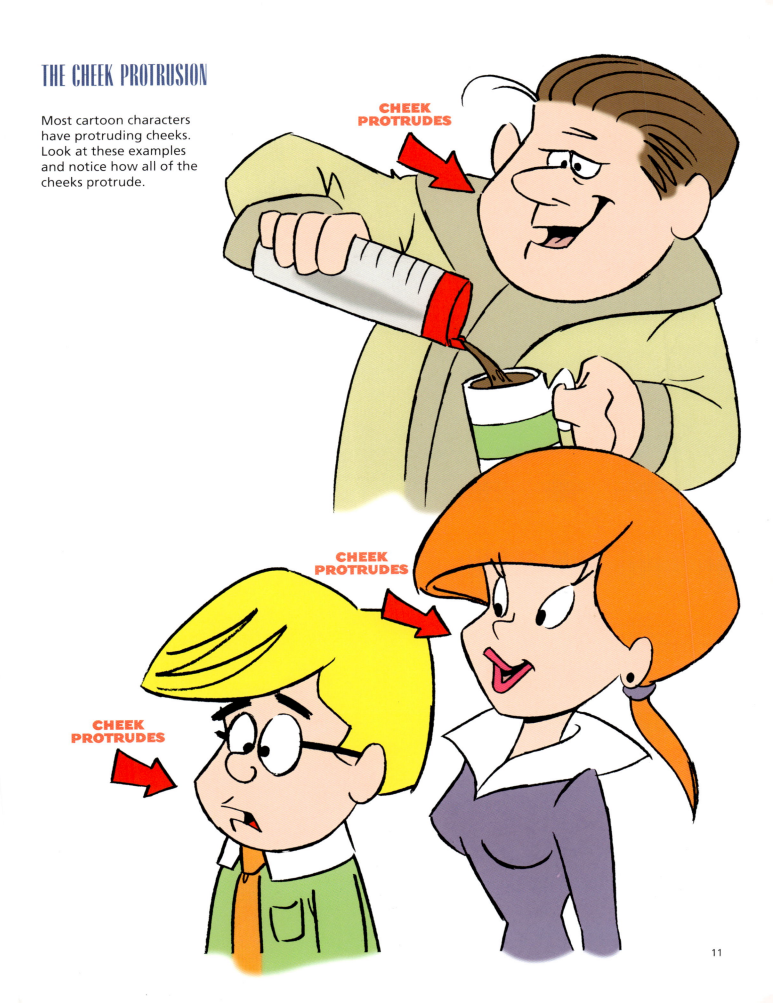

CHEEK PROTRUDES

CHEEK PROTRUDES

CHEEK PROTRUDES

TILTING THE HEAD

Most beginning cartoonists stick with one or two of their favorite angles, never learning how to rotate the head in other directions. This is a mistake, because you'll end up staging scenes poorly to accommodate your inability to draw certain angles. If you keep in mind that your character's head is a three-dimensional object, you can reduce it to its simplest form. Then it suddenly becomes much easier to rotate.

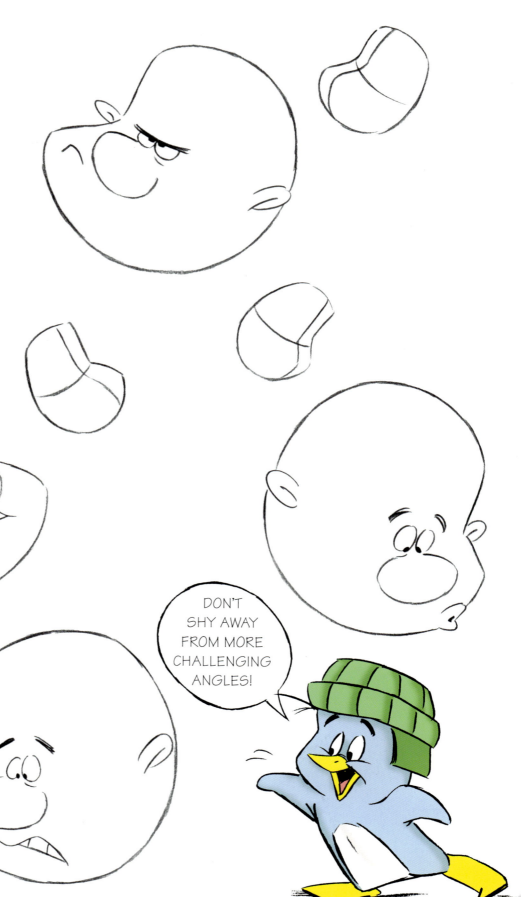

DON'T SHY AWAY FROM MORE CHALLENGING ANGLES!

A professional cartoonist must be able to draw a character in different positions while making sure it always looks like the *same* character. This is especially important for drawing comic strips and animation.

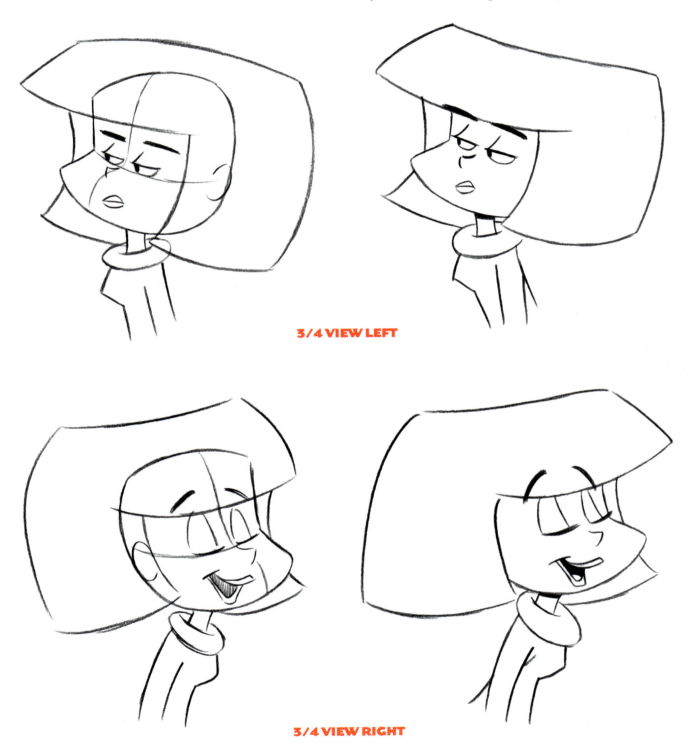

3/4 VIEW LEFT

3/4 VIEW RIGHT

PROPORTIONS—KIDS VS. ADULTS

Up 'til now, I've been showing you how to draw adults. But different ages require different head shapes. You can't just draw big, round eyes and lots of shaggy hair on an adult-shaped head and expect it to look like a kid. A kid's head has its own special shape.

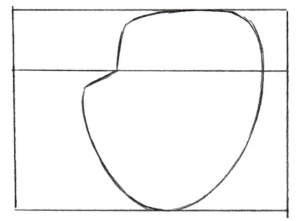

The older the character is, the smaller the forehead will be. Also, an older character's eyes are placed higher up on his head.

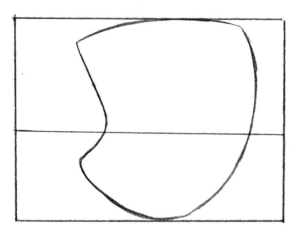

Younger characters have large foreheads (think of babies) and eyes placed low on the head. They also typically have smaller noses and ears than older characters.

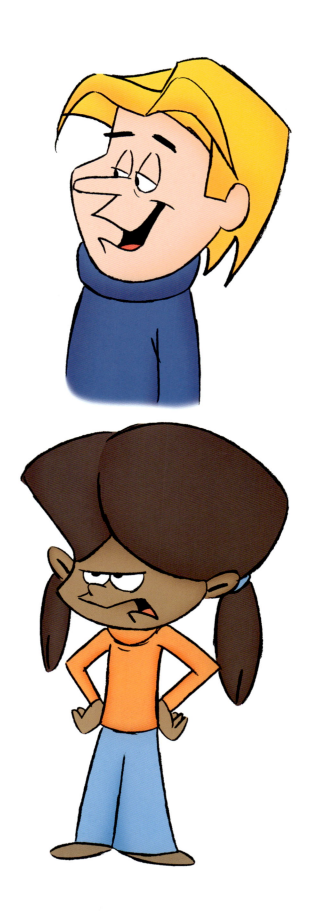

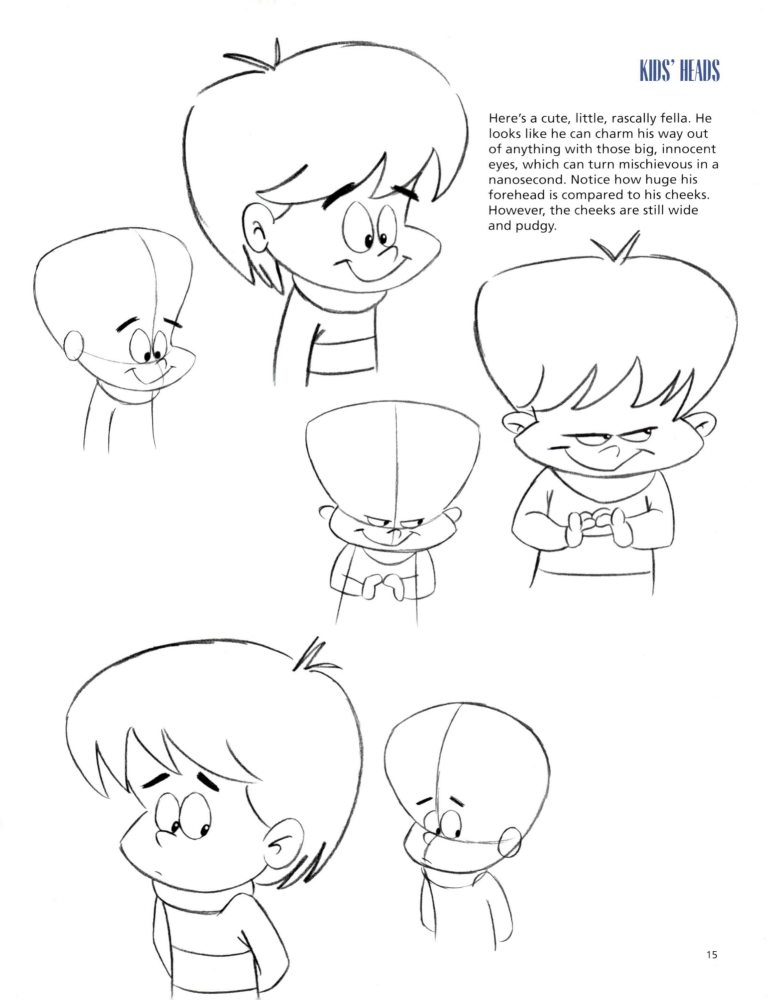

Here's a cute, little, rascally fella. He looks like he can charm his way out of anything with those big, innocent eyes, which can turn mischievous in a nanosecond. Notice how huge his forehead is compared to his cheeks. However, the cheeks are still wide and pudgy.

DIFFERENT CHARACTERS REQUIRE DIFFERENT HEAD SHAPES

There are many subtle variations on the basic cartoon head. Here are some sample head shapes, based on classic character types, for your future cartoon creations.

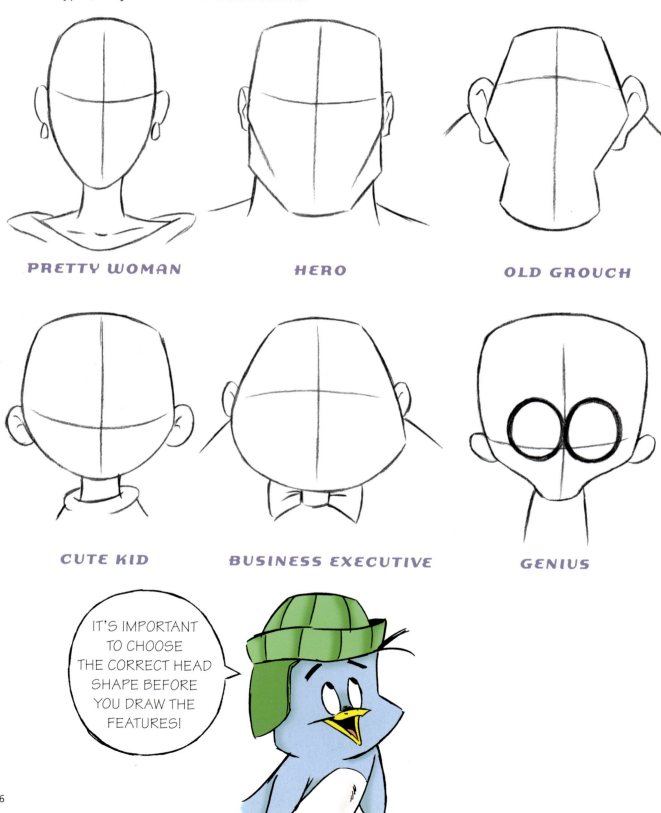

PRETTY WOMAN

HERO

OLD GROUCH

CUTE KID

BUSINESS EXECUTIVE

GENIUS

IT'S IMPORTANT TO CHOOSE THE CORRECT HEAD SHAPE BEFORE YOU DRAW THE FEATURES!

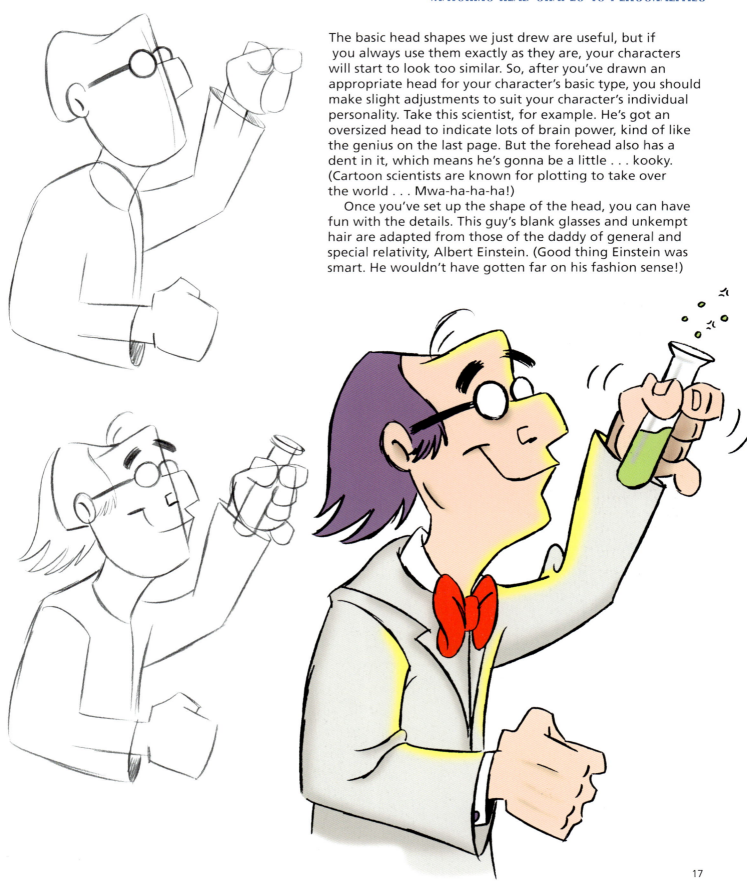

The basic head shapes we just drew are useful, but if you always use them exactly as they are, your characters will start to look too similar. So, after you've drawn an appropriate head for your character's basic type, you should make slight adjustments to suit your character's individual personality. Take this scientist, for example. He's got an oversized head to indicate lots of brain power, kind of like the genius on the last page. But the forehead also has a dent in it, which means he's gonna be a little . . . kooky. (Cartoon scientists are known for plotting to take over the world . . . Mwa-ha-ha-ha!)

Once you've set up the shape of the head, you can have fun with the details. This guy's blank glasses and unkempt hair are adapted from those of the daddy of general and special relativity, Albert Einstein. (Good thing Einstein was smart. He wouldn't have gotten far on his fashion sense!)

DRAWING THE NECK

This area of the body perplexes many less experienced artists, who tend to draw very skinny necks. The neck is a thick collection of muscles. It needs to be strong to keep the skull upright for twelve hours at a time. Cartoon characters may have skinny necks, but you will draw your 'toons better if you first have an understanding of how the real human neck works.

The two largest muscles in the neck, which you can often see bulging under the skin, are called the *sternomastoids*. They attach to the collarbone, one on each side.

Check out our hero character once more. If you were to put a skinny neck on this guy, he would look like one weird dude. That's the lesson here: The neck has to match the body type. It's a *part* of the body, not just something unimportant that connects the head to the body.

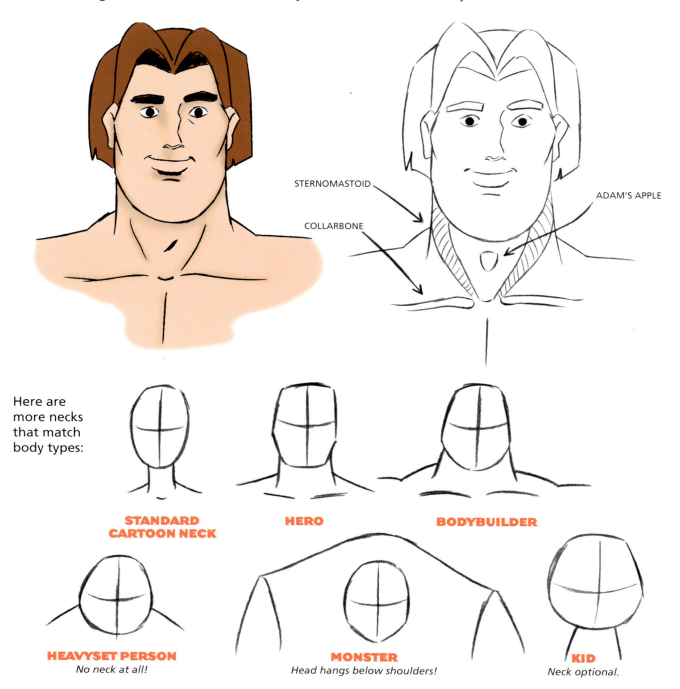

STERNOMASTOID

COLLARBONE

ADAM'S APPLE

Here are more necks that match body types:

STANDARD CARTOON NECK

HERO

BODYBUILDER

HEAVYSET PERSON
No neck at all!

MONSTER
Head hangs below shoulders!

KID
Neck optional.

USING A SIMPLIFIED FORM OF THE SKELETON TO CREATE CARTOON HEADS

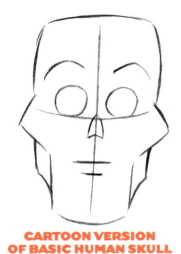

CARTOON VERSION OF BASIC HUMAN SKULL

As you advance as a cartoonist, you will undoubtedly find yourself borrowing more and more from real life, spinning it through your imagination, and turning out cartoons.

Therefore, to draw people, we go to the source—*people!* By using a simplified cartoon version of a human skeleton's head (of course, I'm talking about a *skull,* but that sounds kinda creepy!), we can create a ton of different characters, such as the ones below.

INITIAL CONSTRUCTION

The finished drawing looks impossible to create from a beginner's point of view. But look how clear and simple the initial construction is. It's actually no more difficult than the rounder faces we drew at the opening of the chapter. Give it a go!

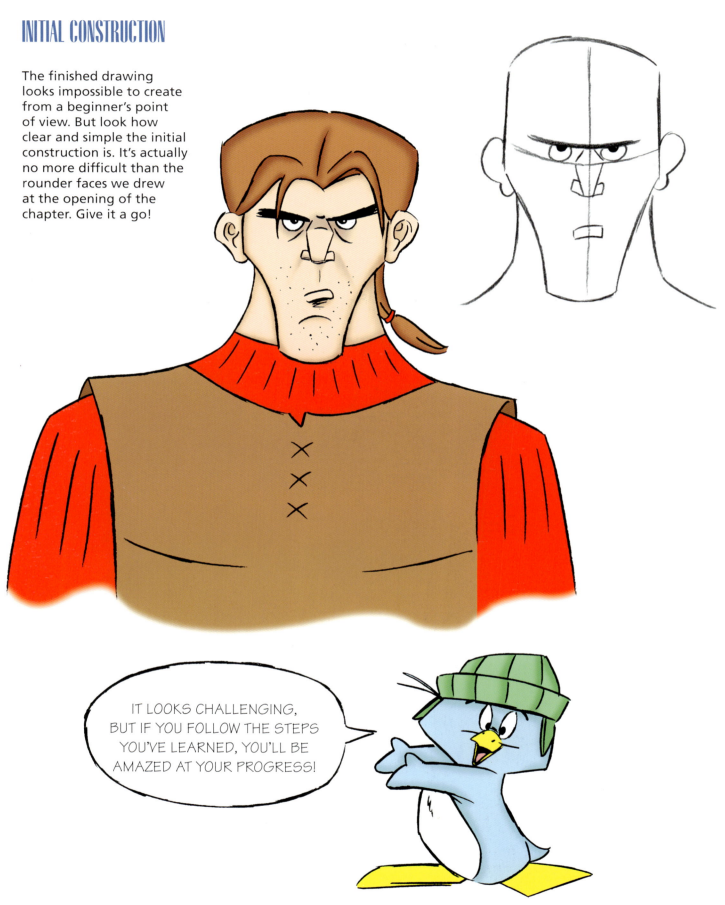

IT LOOKS CHALLENGING, BUT IF YOU FOLLOW THE STEPS YOU'VE LEARNED, YOU'LL BE AMAZED AT YOUR PROGRESS!

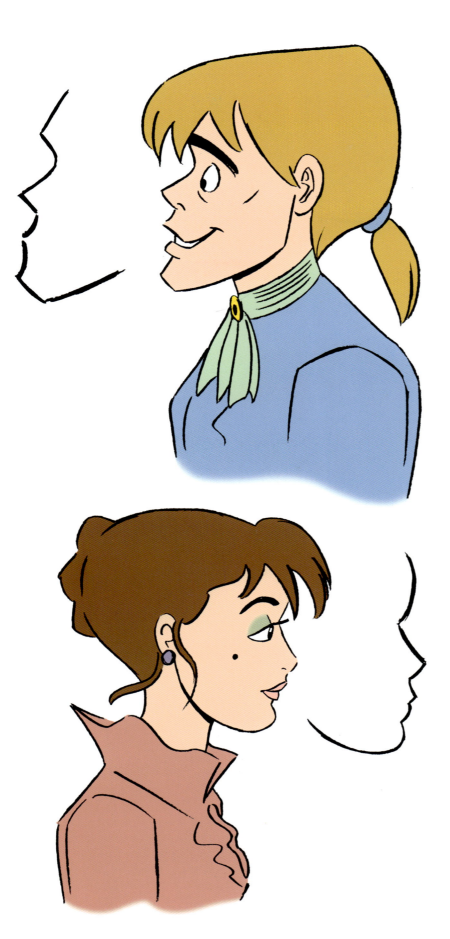

The more realistic a cartoon character is supposed to look, the more important it is for the cartoonist to understand the angles and contours of the face. Without this knowledge, the artist will be unable to draw a convincing profile. Note the big curve of the forehead, followed by the long sweep of the nose, then the smaller, sharper angles of the upper lip, lower lip, and chin. We'll cover "realistic" cartoon characters in more depth later on.

DRAWING EYES

The eyes can communicate thoughts, feelings, and expressions better than any other part of the body. Just ask any kid who has done something wrong and, as a result, has gotten "that look" from his father. Don't leave the expression up to the eyebrows alone; that's asking them to shoulder too much of the work. It's crucial to understand that the shape of the eye, as well as the shape of the pupil, actually changes, depending on the expression.

In animated cartoons, expressive eyes play a huge role in conveying characters' feelings. However, in newspapers, comic strips are reduced to such a small size that eye expressions become less important. Some famous comic strip characters, like Beetle Bailey, don't show any eyes at all!

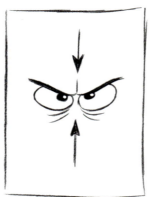

SQUASH **STRETCH**

SQUASH AND STRETCH

In some expressions—like anger, hilarity, and suspicion—the eyebrows crush down on the eyes, *squashing* them and causing them to get shorter and wider.

In other expressions—such as happiness, surprise, and shock—the eyebrows rise up, *stretching* the eyeball and making it taller and thinner.

Eyes look right. Tilt left.

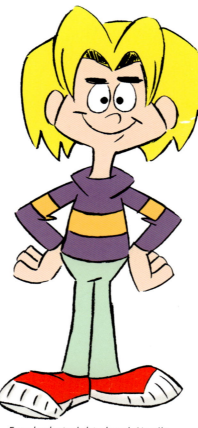

Eyes look straight ahead. No tilt.

Eyes look left. Tilt right.

THE PUPILS

Pupils are drawn as small, neat balls with a shine on them. When a character is gazing up, down, or to the side, you can add emphasis to the look by allowing the eyeball to "cut off" the pupil so that you only see part of it pressed up against the side of the eye.

SHIFTING EYE DIRECTION

When drawing a character looking to the left or right, you can strengthen the expression by *tilting* the eyes in the opposite direction. This makes the expression clearer and funnier. Paying attention to subtleties like this may seem like a lot of work, but the eyes are one area where subtle details really pay off.

EYES AND EMOTIONS

You should be able to tell what your character is thinking merely by the look in his or her eyes. Here are some typical cartoon eye expressions which are easily identifiable by readers and audiences.

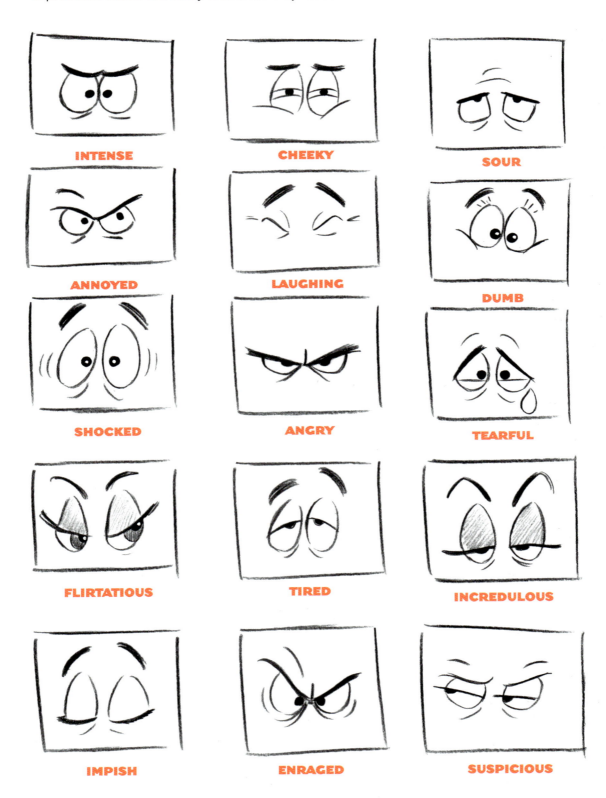

INTENSE

CHEEKY

SOUR

ANNOYED

LAUGHING

DUMB

SHOCKED

ANGRY

TEARFUL

FLIRTATIOUS

TIRED

INCREDULOUS

IMPISH

ENRAGED

SUSPICIOUS

NOW HEAR THIS: DRAWING EARS

The realistic ear is quite a complex form to draw. Cartoonists have simplified it so that it still reads as an ear, but in a funny way. Below are the six most popular methods of drawing the cartoon ear. Shapes more complex than this will distract the reader from the rest of the cartoon face.

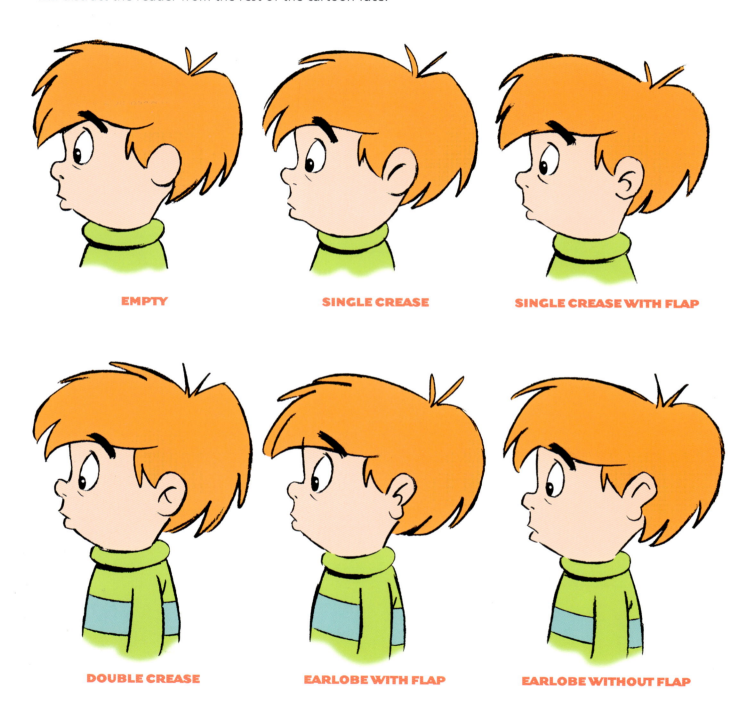

EMPTY

SINGLE CREASE

SINGLE CREASE WITH FLAP

DOUBLE CREASE

EARLOBE WITH FLAP

EARLOBE WITHOUT FLAP

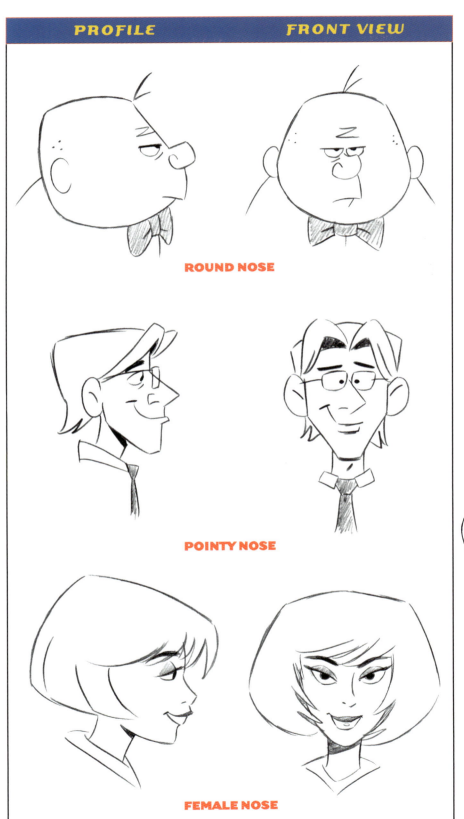

PROFILE	FRONT VIEW

ROUND NOSE

POINTY NOSE

FEMALE NOSE

One of the most puzzling things about drawing noses is getting them to look the same in the *front view* as they do in the *profile* (side view). In the profile, the nose sticks out considerably. But in the front view, *foreshortening* flattens it out. (We'll discuss foreshortening more later.) Cartoonists "cheat" by drawing the front-view nose as a modified profile nose. Take a look at the examples in the box at left.

COMPARED TO HUMAN NOSES, MINE IS A SNAP!

THE INNER MOUTH

When a character opens his or her mouth to talk, shout, laugh, or cry, the cartoonist is suddenly faced with a decision: what to do about the interior of the mouth. The inside of the mouth is comprised of four different elements: teeth, uvula, tongue, and throat.

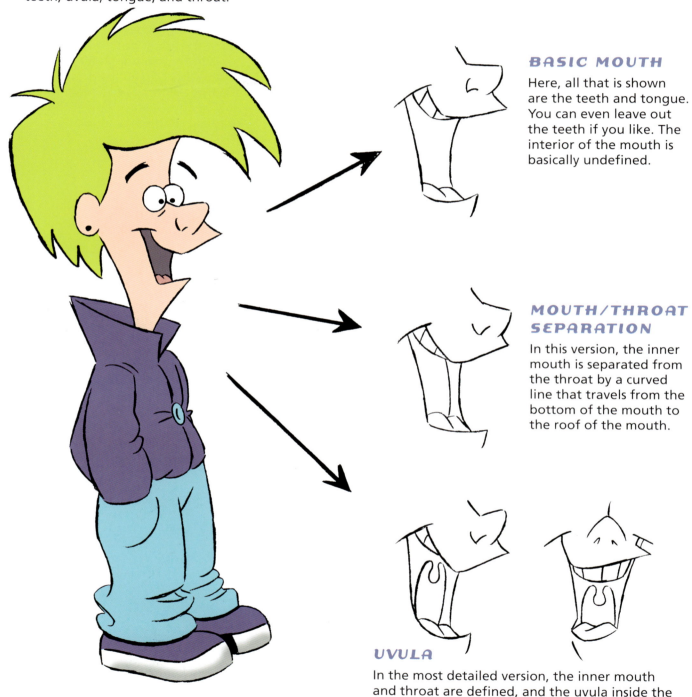

BASIC MOUTH

Here, all that is shown are the teeth and tongue. You can even leave out the teeth if you like. The interior of the mouth is basically undefined.

MOUTH/THROAT SEPARATION

In this version, the inner mouth is separated from the throat by a curved line that travels from the bottom of the mouth to the roof of the mouth.

UVULA

In the most detailed version, the inner mouth and throat are defined, and the uvula inside the throat is also defined. This method works best in the front view, when the audience or reader is looking straight down a character's throat.

The teeth are the icing on the cake for any mouth expression. Drawn correctly, they add that little accent that helps a character to stand out.

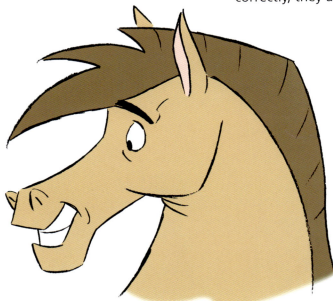

The top and bottom front teeth should slant inward, toward each other, and meet in the middle.

INCORRECTLY DRAWN TEETH

This horse's teeth are bland. There's no form to them; they're just a white mass with a line drawn through it. We can do better than that!

The back of the mouth should show an empty space behind the teeth.

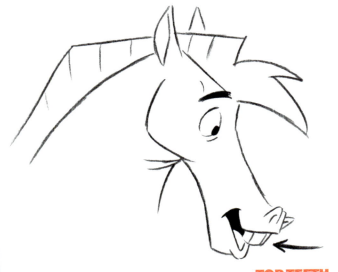

TOP TEETH
When a character is happy, the top teeth show.

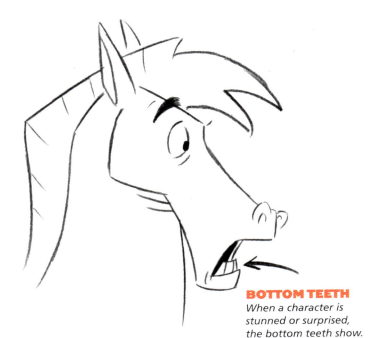

BOTTOM TEETH
When a character is stunned or surprised, the bottom teeth show.

DRAWING LIPS

Most cartoon women, especially if they are pretty, are drawn with full lips. Leading men and male hero characters are also drawn with full lips.

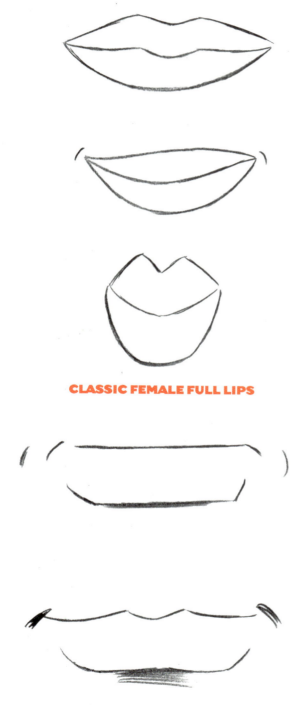

CLASSIC FEMALE FULL LIPS

CLASSIC MALE FULL LIPS

HERE ARE SOME EXAMPLES OF CLASSIC CARTOON-STYLE FULL LIPS.

It was hard to get Quentin to pose for this. It took over four pounds of krill and a lot of begging, but it was worth it. Once you've finalized your character's head, practice as many poses as possible. You may need them later on!

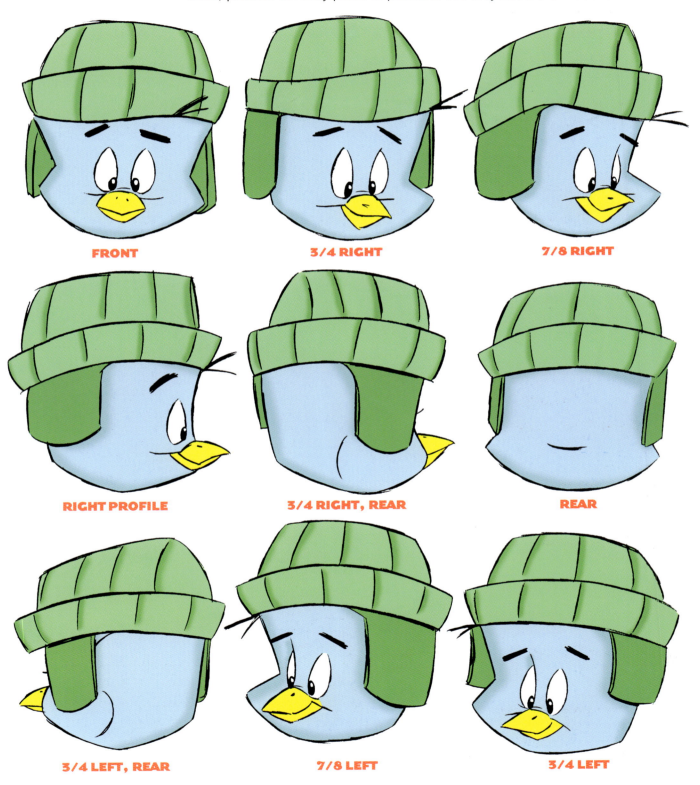

FRONT

3/4 RIGHT

7/8 RIGHT

RIGHT PROFILE

3/4 RIGHT, REAR

REAR

3/4 LEFT, REAR

7/8 LEFT

3/4 LEFT

DRAWING Bodies

Cartoon bodies are, naturally, greatly simplified versions of human anatomy. However, a few principles of "real" anatomy must still be in evidence. Try to include some of these points when you design your characters' bodies.

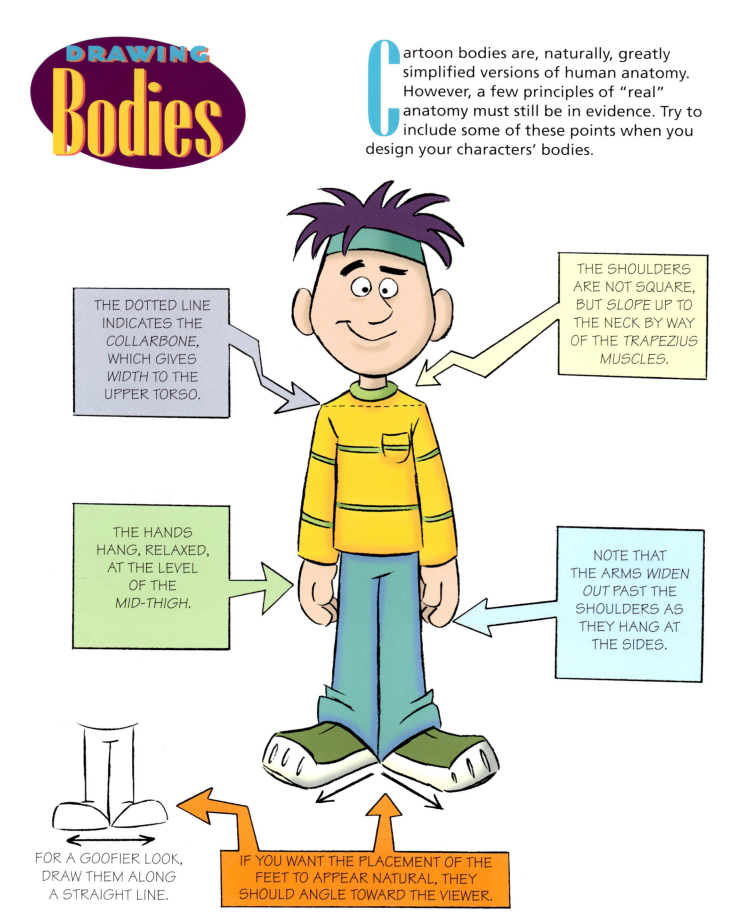

THE DOTTED LINE INDICATES THE *COLLARBONE*, WHICH GIVES *WIDTH* TO THE UPPER TORSO.

THE SHOULDERS ARE NOT SQUARE, BUT *SLOPE* UP TO THE NECK BY WAY OF THE *TRAPEZIUS* MUSCLES.

THE HANDS HANG, RELAXED, AT THE LEVEL OF THE MID-THIGH.

NOTE THAT THE ARMS *WIDEN OUT* PAST THE SHOULDERS AS THEY HANG AT THE SIDES.

FOR A GOOFIER LOOK, DRAW THEM ALONG A STRAIGHT LINE.

IF YOU WANT THE PLACEMENT OF THE FEET TO APPEAR NATURAL, THEY SHOULD ANGLE TOWARD THE VIEWER.

If you look carefully, you'll notice something surprising about the upper body: It doesn't stand straight up. Instead, it is pulled in the direction of the head and neck, which hang slightly forward.

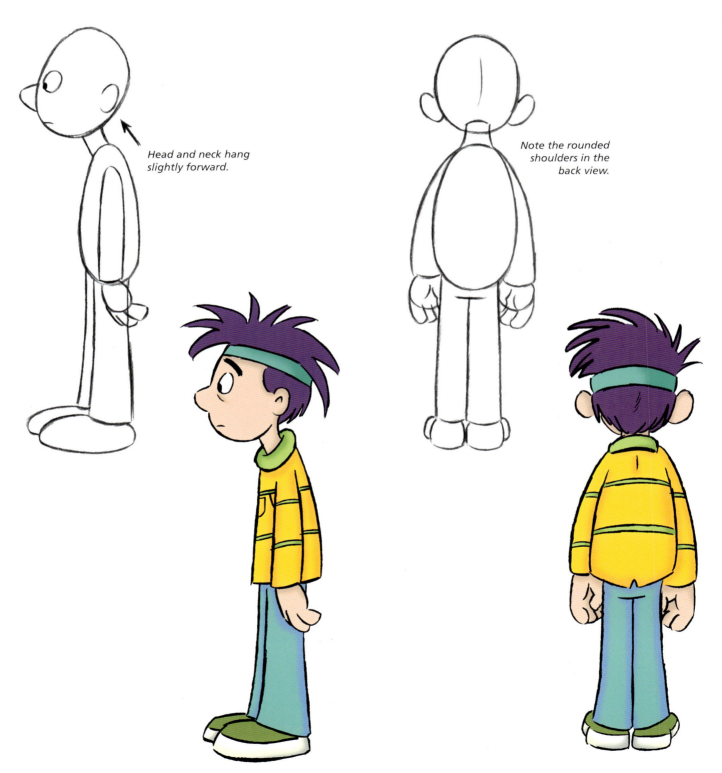

Head and neck hang slightly forward.

Note the rounded shoulders in the back view.

MATCHING BODY TYPES TO PERSONALITIES

Broadly drawn cartoon bodies are generally based on a single shape—that of the torso. Like the head shape, the shape of the torso must match the character type. For example, a goofy character should have a goofy body shape, not the body shape of a hero or baby.

Quentin's body is pear-shaped, which is typical of a cute character.

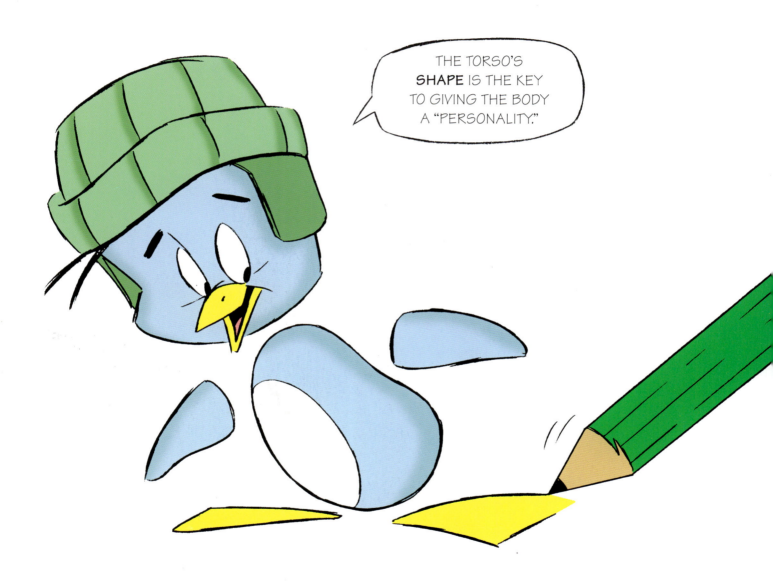

THE TORSO'S **SHAPE** IS THE KEY TO GIVING THE BODY A "PERSONALITY."

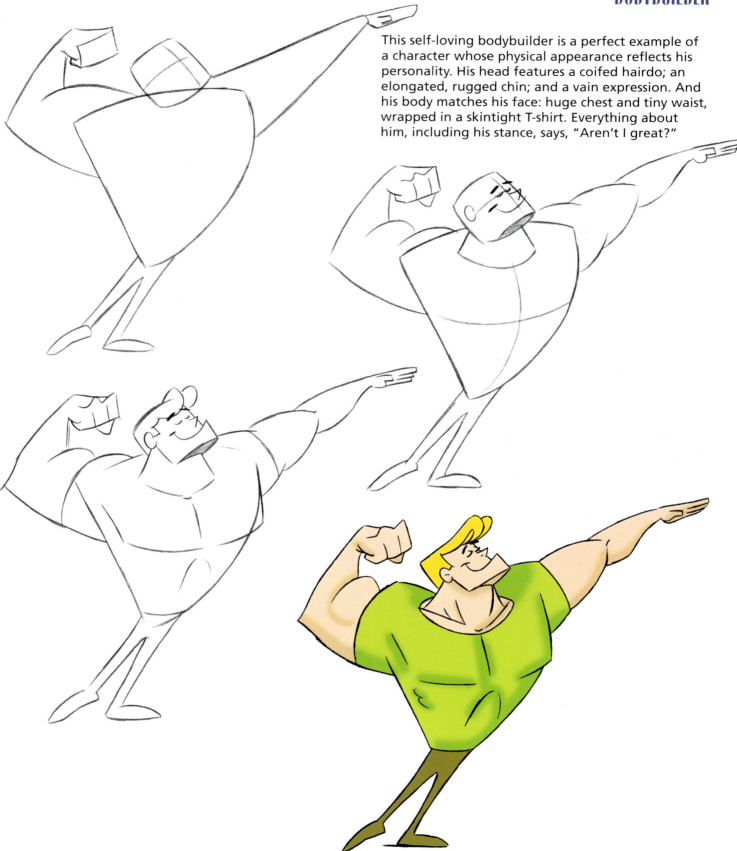

This self-loving bodybuilder is a perfect example of a character whose physical appearance reflects his personality. His head features a coifed hairdo; an elongated, rugged chin; and a vain expression. And his body matches his face: huge chest and tiny waist, wrapped in a skintight T-shirt. Everything about him, including his stance, says, "Aren't I great?"

COOL TEEN

Note this character's lanky torso, long arms, and big hands. He looks as if he hasn't quite grown into his frame yet. While costuming helps to create the character, matching the body type to the personality is where good character design really begins.

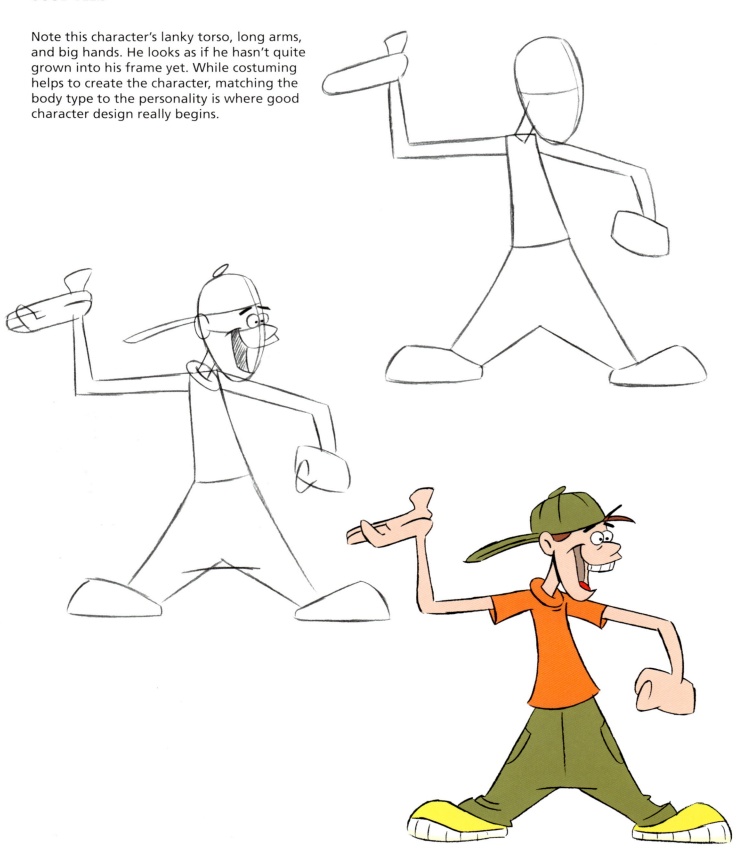

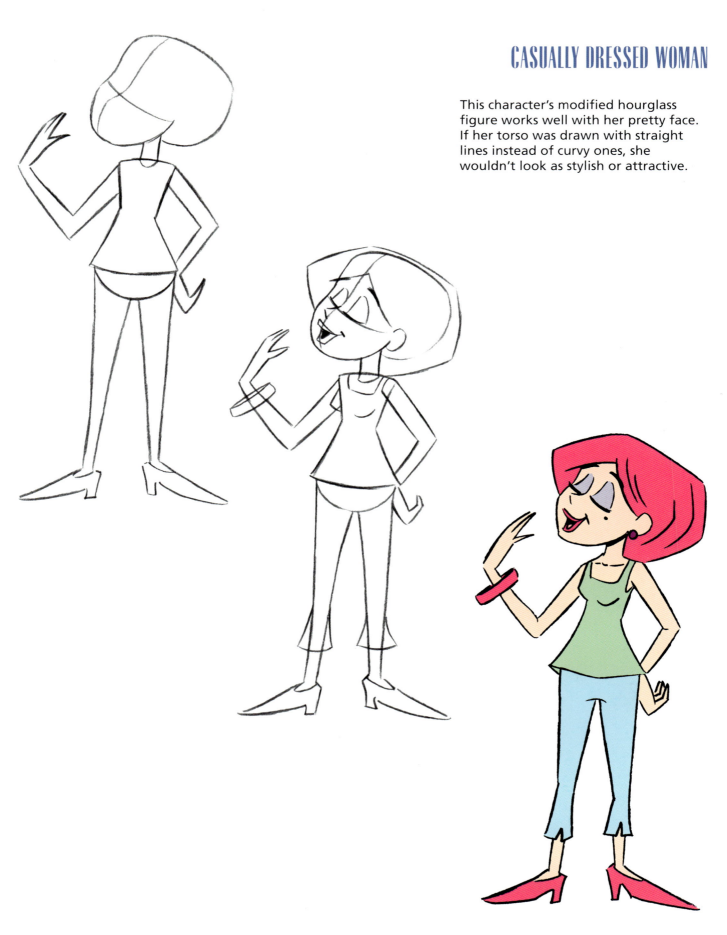

CASUALLY DRESSED WOMAN

This character's modified hourglass figure works well with her pretty face. If her torso was drawn with straight lines instead of curvy ones, she wouldn't look as stylish or attractive.

DRAWING HANDS

Just as you would begin to sketch the body by drawing its overall form, you should begin to sketch the hand as one form as well—drawing one shape to represent both the palm and the fingers. Then, as you progress, start to chip away at the details.

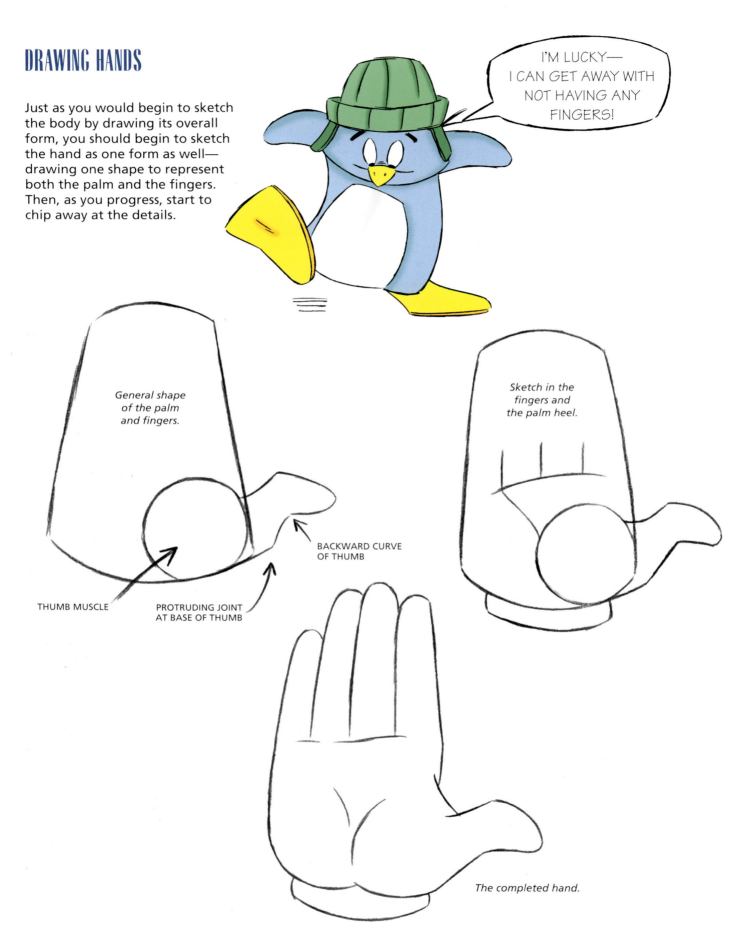

I'M LUCKY— I CAN GET AWAY WITH NOT HAVING ANY FINGERS!

General shape of the palm and fingers.

THUMB MUSCLE

PROTRUDING JOINT AT BASE OF THUMB

BACKWARD CURVE OF THUMB

Sketch in the fingers and the palm heel.

The completed hand.

HAND TYPES

THIN

REGULAR

FEMALE
*Pointed fingertips
read as nails.*

KID
*Oversize hand
with skinny wrist.*

**CORPULENT
WOMAN**
*Note the
dimpled
knuckles.*

CLASSIC CARTOON HANDS

The semi-realistic-looking characters that populate animated movies such as the Disney and Don Bluth features usually have four-fingered hands, while most comic strip characters have only three fingers and a thumb.

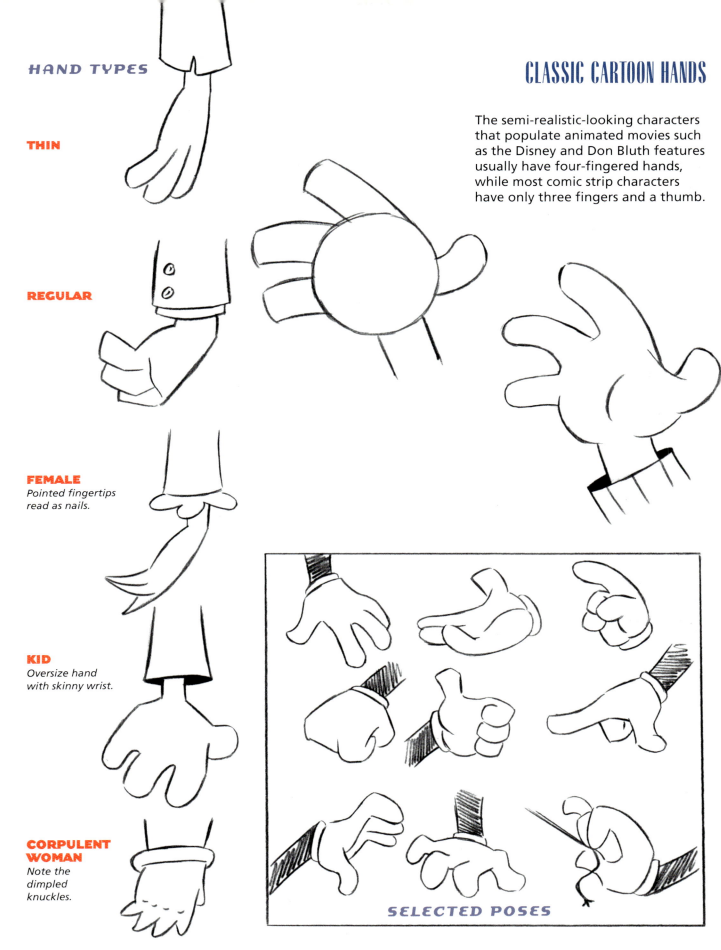

SELECTED POSES

DRAWING SHOES AND FEET

Inexperienced artists tend to hide feet and gloss over shoes, because they're difficult to draw. Unfortunately, there is no magic formula for learning how to render the southernmost part of the body; it just takes practice! However, it's helpful to see how other cartoonists interpret feet and footwear, because it starts you thinking in cartoon terms. Here are some good examples . . .

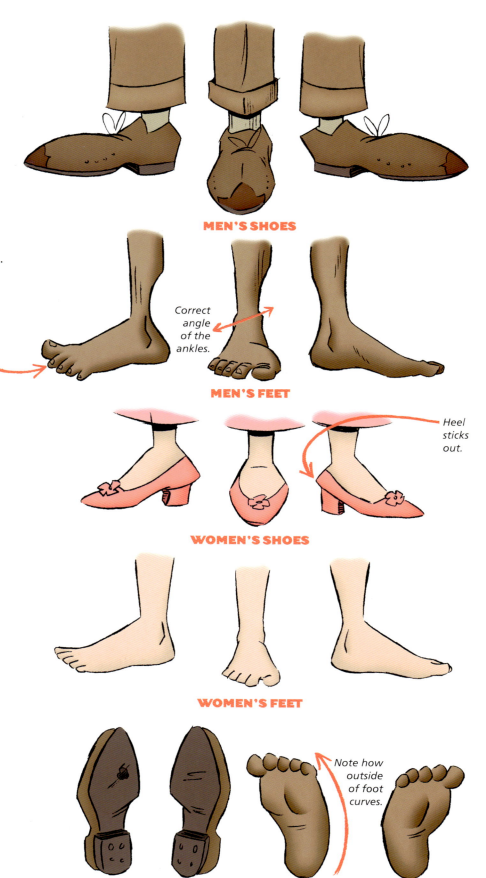

MEN'S SHOES

Second toe is longest.

Correct angle of the ankles.

MEN'S FEET

Heel sticks out.

WOMEN'S SHOES

WOMEN'S FEET

Note how outside of foot curves.

UNDERSIDE OF SHOES

UNDERSIDE OF FEET

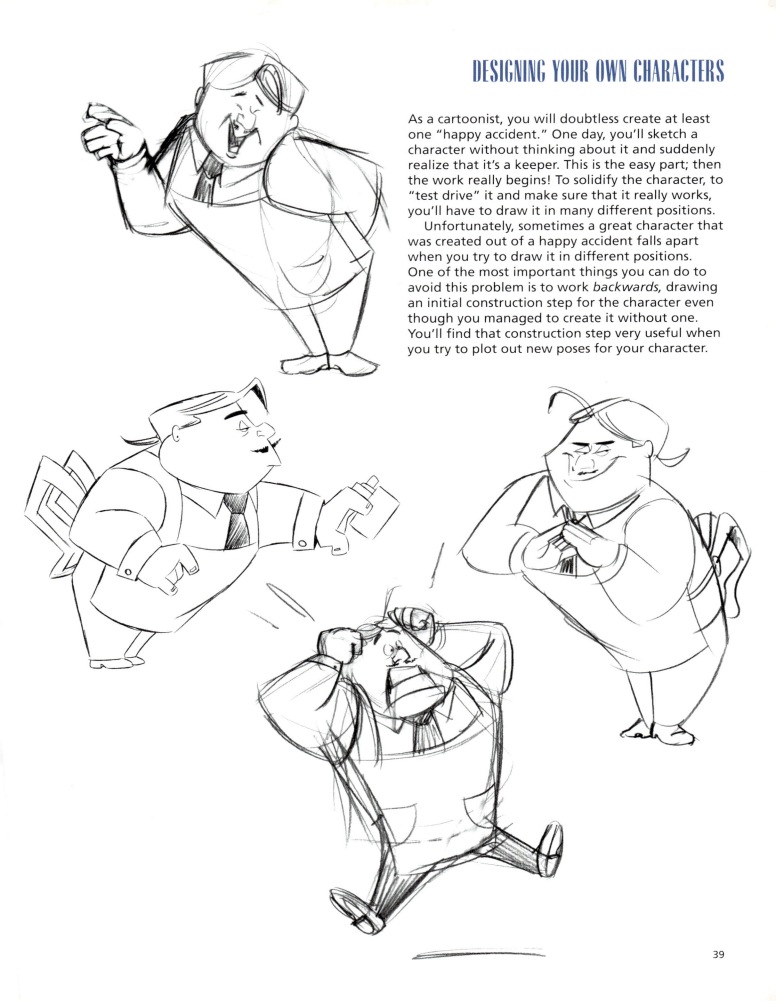

DESIGNING YOUR OWN CHARACTERS

As a cartoonist, you will doubtless create at least one "happy accident." One day, you'll sketch a character without thinking about it and suddenly realize that it's a keeper. This is the easy part; then the work really begins! To solidify the character, to "test drive" it and make sure that it really works, you'll have to draw it in many different positions.

Unfortunately, sometimes a great character that was created out of a happy accident falls apart when you try to draw it in different positions. One of the most important things you can do to avoid this problem is to work *backwards,* drawing an initial construction step for the character even though you managed to create it without one. You'll find that construction step very useful when you try to plot out new poses for your character.

GO FOR ATTITUDES

Don't just give your character a pose. Go for attitudes, scenes, intentions. If you plan to use the character for a while, you have to be able to think his thoughts for him, and you must be able to communicate those thoughts through his facial expressions and body attitudes.

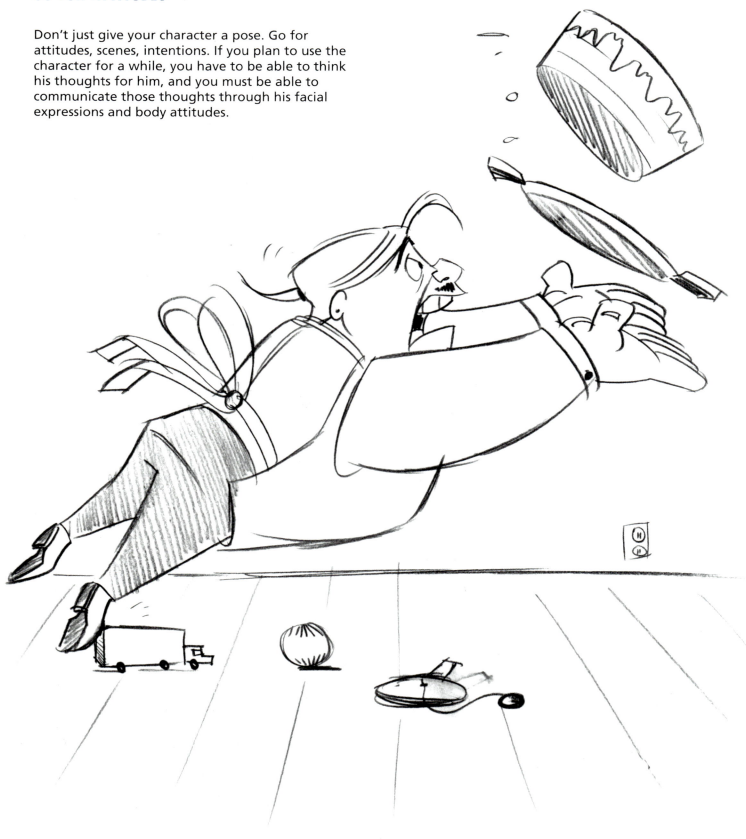

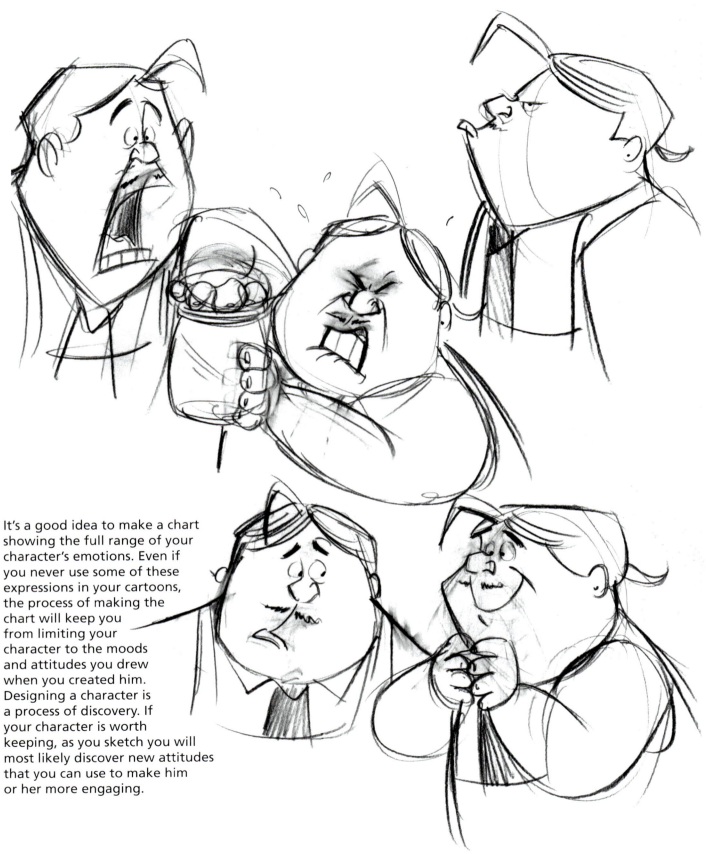

It's a good idea to make a chart showing the full range of your character's emotions. Even if you never use some of these expressions in your cartoons, the process of making the chart will keep you from limiting your character to the moods and attitudes you drew when you created him. Designing a character is a process of discovery. If your character is worth keeping, as you sketch you will most likely discover new attitudes that you can use to make him or her more engaging.

THE Action Line

THE "ACTION LINE" IS THE FOUNDATION OF GOOD POSES!

It's a contradiction: You're supposed to think of the body as separate parts that are joined together to form a whole. But if all you do is stick a bunch of parts together, your drawing won't seem unified. To make sure your drawing "flows," start with the *action line.*

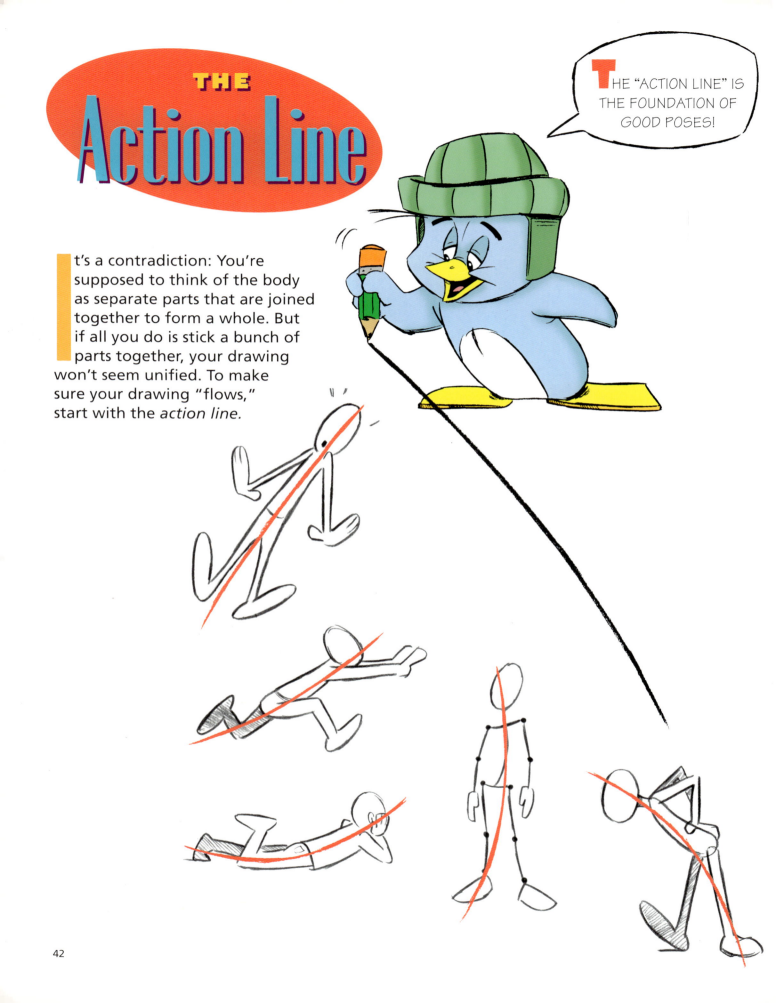

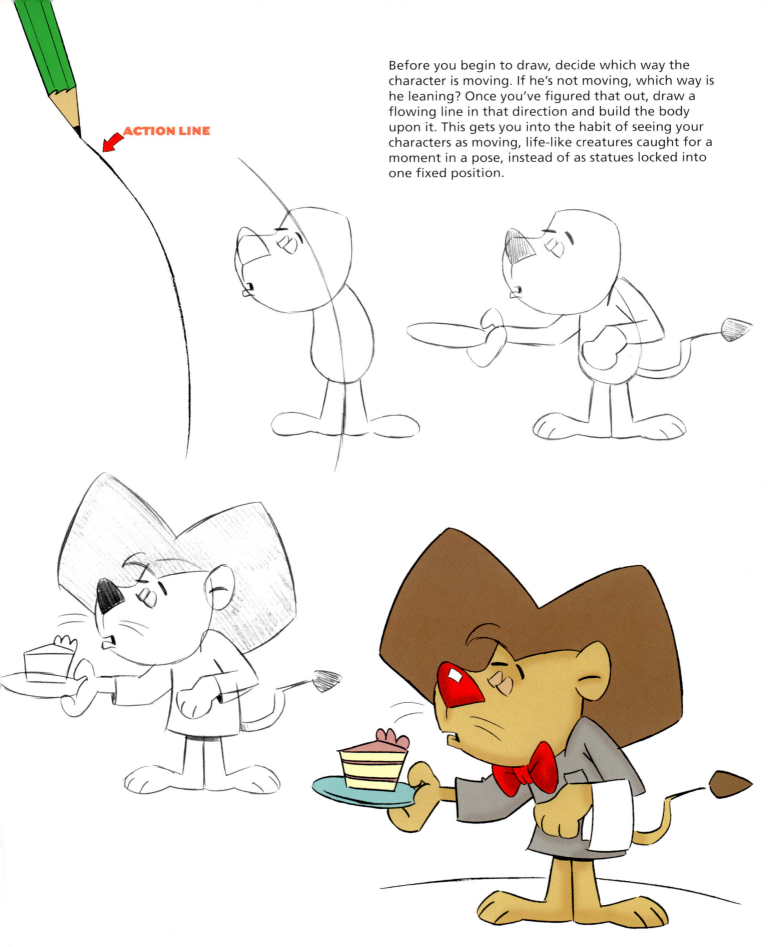

ACTION LINE

Before you begin to draw, decide which way the character is moving. If he's not moving, which way is he leaning? Once you've figured that out, draw a flowing line in that direction and build the body upon it. This gets you into the habit of seeing your characters as moving, life-like creatures caught for a moment in a pose, instead of as statues locked into one fixed position.

THE ACTION LINE IN ACTION

The action line is most crucial when a pose involves a motion such as running, walking, throwing, or skiing. It's true that to achieve comic effects, cartoonists sometimes purposely avoid action lines. For example, they might show a character running while completely upright. But breaking the rules will only look funny if you thoroughly understand them—otherwise, your clever experiment may simply read as a mistake.

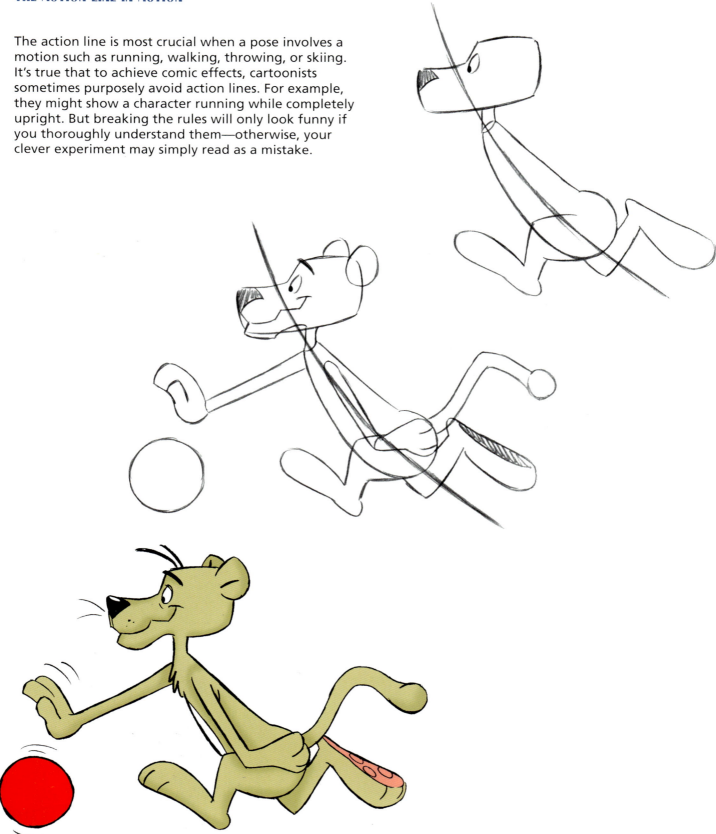

Once you have a little more experience as a cartoonist, you may not need to actually draw every action line. Because you'll be thinking in terms of action, direction, and flow, your poses will naturally have them. Sometimes I only draw the spine of the character to start, and use that as my action line.

These poses were drawn without the action lines being sketched in at the outset. However, you can see that the flow of the poses is still very much in evidence.

TWO CHARACTERS REQUIRE TWO ACTION LINES

Give each character its own action line. Sometimes the action lines will complement each other by going in the same direction, but they don't have to. In this drawing, the action lines are perpendicular to each other.

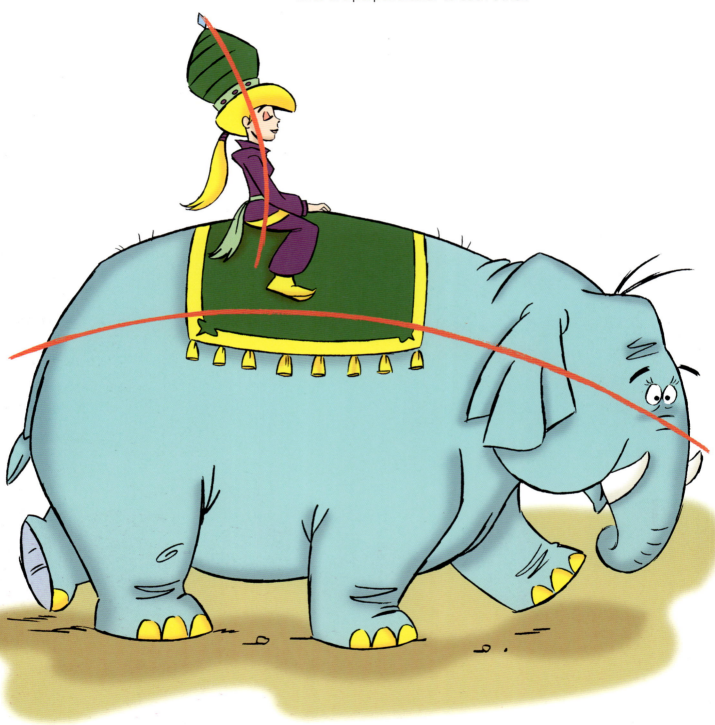

CAN YOU SEE THE ACTION LINE HIDDEN IN THIS PICTURE?

Knowing what you now know, you can see the action line at work in this pose. The arms aren't part of the overall thrust of the pose, therefore, the action line doesn't go through them. Instead, it travels in an upward curve from the feet through the body and up through the neck.

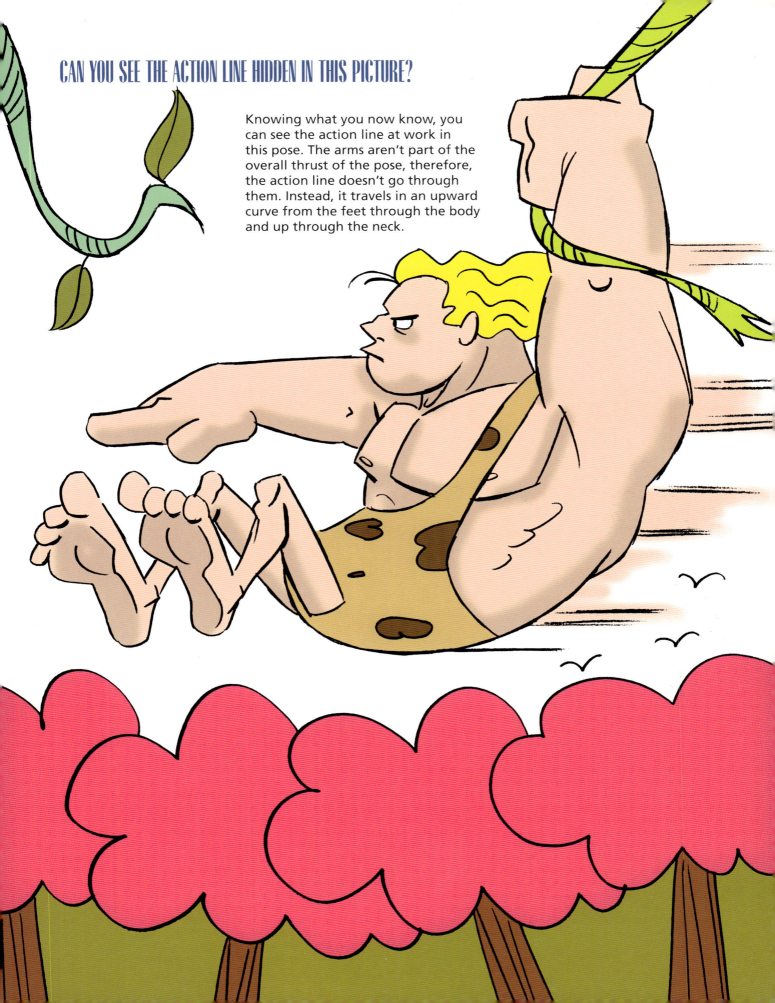

CARTOON WALKS

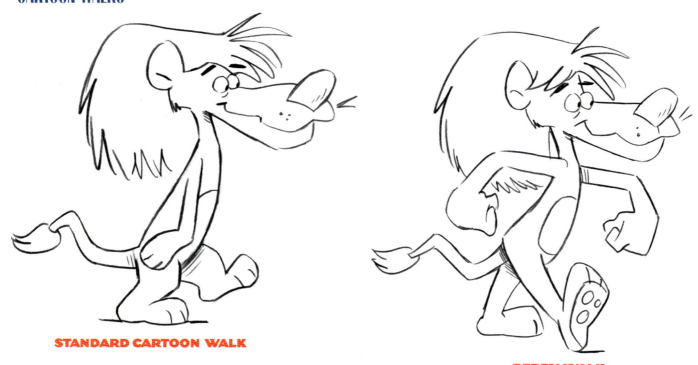

STANDARD CARTOON WALK

PEPPY WALK

Movements such as walks and runs can say as much about a character as a facial expression or body attitude. A character's walk can be tailor-made to be as unique as his or her personality. Here are a few popular cartoon walks.

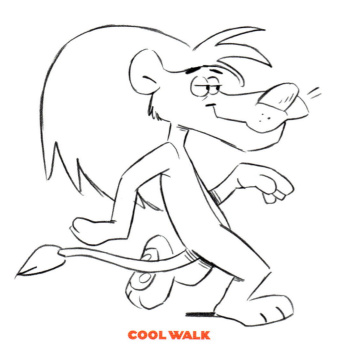

COOL WALK

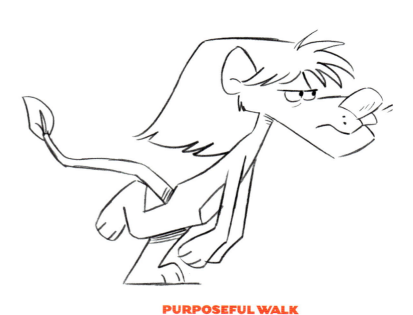

PURPOSEFUL WALK

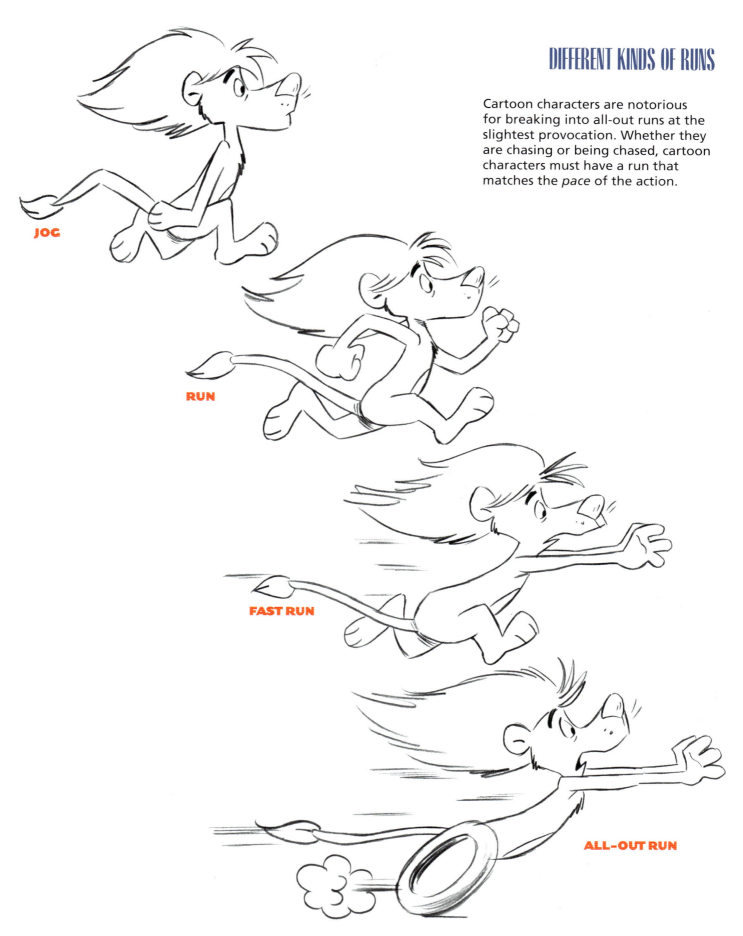

DIFFERENT KINDS OF RUNS

Cartoon characters are notorious for breaking into all-out runs at the slightest provocation. Whether they are chasing or being chased, cartoon characters must have a run that matches the *pace* of the action.

JOG

RUN

FAST RUN

ALL-OUT RUN

THE TEN
Most Common Mistakes
MADE BY BEGINNING CARTOONISTS
—AND HOW TO AVOID THEM!

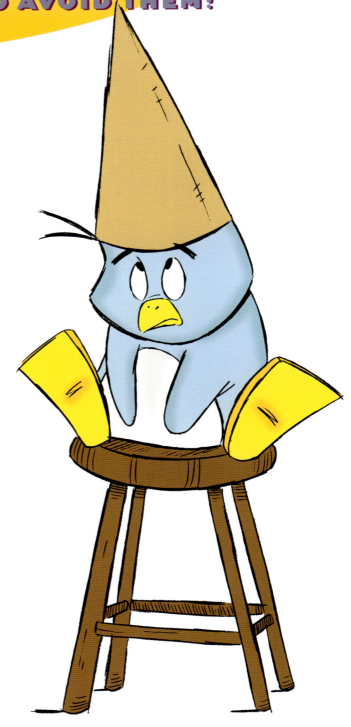

Everyone makes mistakes, even professional cartoonists. That's why we have erasers! However, the mistakes that professionals make tend to be both less serious and less conspicuous than the mistakes made by inexperienced cartoonists. If you avoid the *ten most common mistakes* made by beginners, you can prevent your work from appearing amateurish. I'll show you these popular blunders and how to correct them easily. These lessons, combined with what you have already learned, should greatly improve your skill level.

DRAWING TOO LIGHTLY OR PRESSING TOO HARD ON YOUR PENCIL

Many beginning artists fall into one of these closely-related traps: They either draw timidly, making halting little scratches that give the image an insecure, feathered look; or they press down very hard, which makes the line wiggle, and makes spontaneity, as well as erasing, difficult.

It is far better to strive for *longer, looser strokes*. Be bold, but don't press hard. If you make a mistake, make it a self-assured one. You probably *will* make a lot of mistakes following this advice, but you will also create lots of happy accidents that you wouldn't have discovered using an overly-cautious, less imaginativeapproach. Allow yourself the freedom to make errors; they are often the greatest source of inspiration.

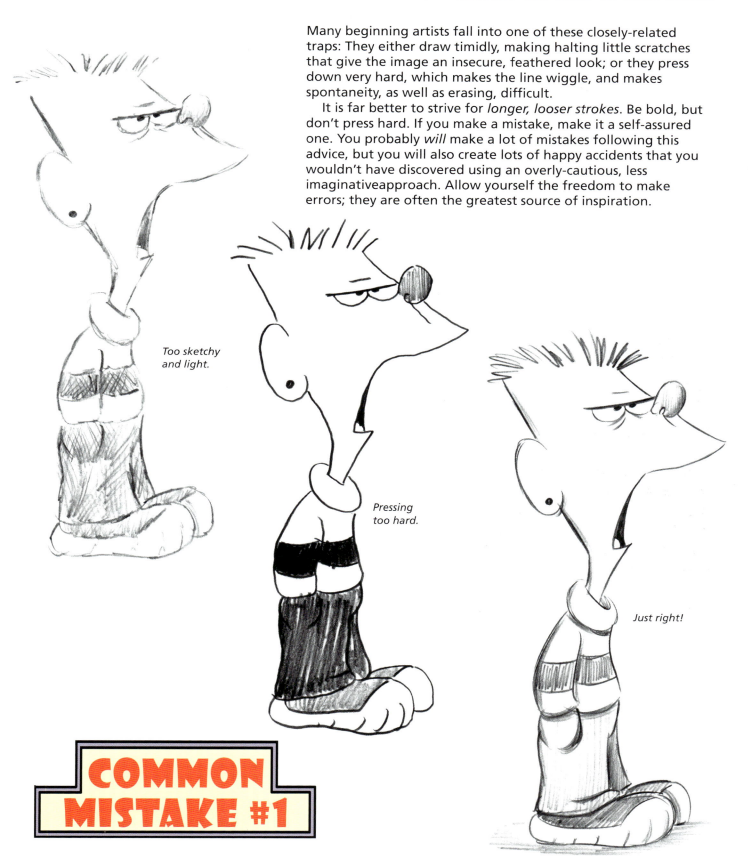

Too sketchy and light.

Pressing too hard.

Just right!

COMMON MISTAKE #1

NOT DRAWING ALL THE LIMBS

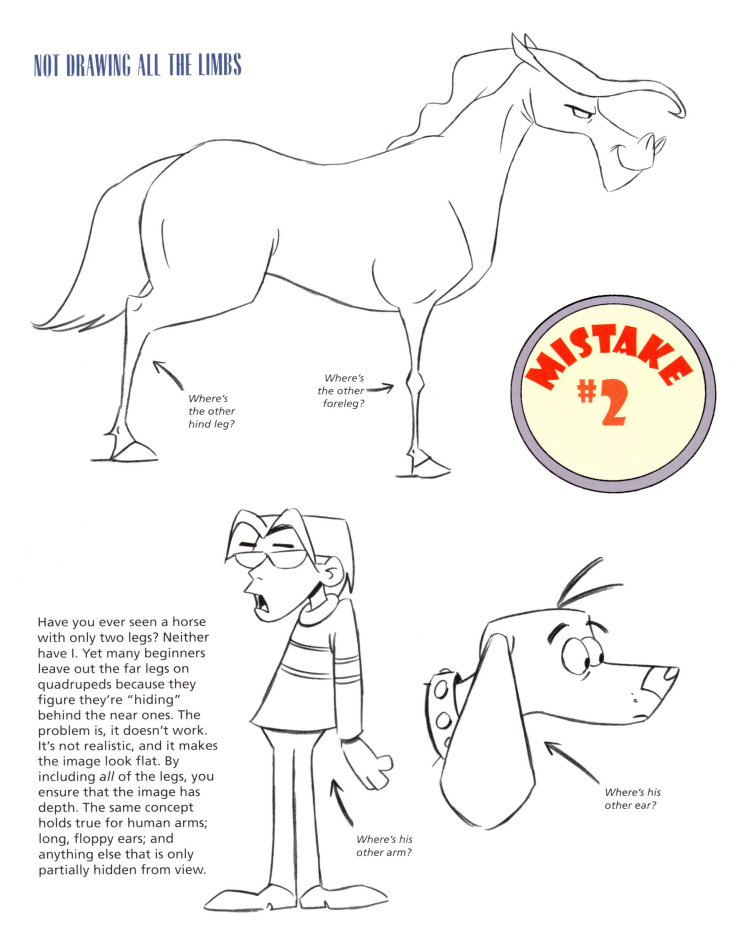

Where's the other hind leg?

Where's the other foreleg?

MISTAKE #2

Have you ever seen a horse with only two legs? Neither have I. Yet many beginners leave out the far legs on quadrupeds because they figure they're "hiding" behind the near ones. The problem is, it doesn't work. It's not realistic, and it makes the image look flat. By including *all* of the legs, you ensure that the image has depth. The same concept holds true for human arms; long, floppy ears; and anything else that is only partially hidden from view.

Where's his other arm?

Where's his other ear?

THE POSE DOESN'T MATCH THE FACIAL EXPRESSION

We've talked a lot in this book about matching heads to body types. It's also important to match the body's "attitude" to the face's "expression." When a dog looks at you with wide eyes, tongue hanging out, and a smile, his body isn't droopy. Most likely, his back is arched and his tail is wagging from side to side, his hips moving along with it. The same principle holds true for other animals, and for humans, too.

UNSUPPORTED EXPRESSION

There's nothing wrong with this pose, but it reads as more of a reaction than an active expression. The body doesn't support the delighted grin on his face.

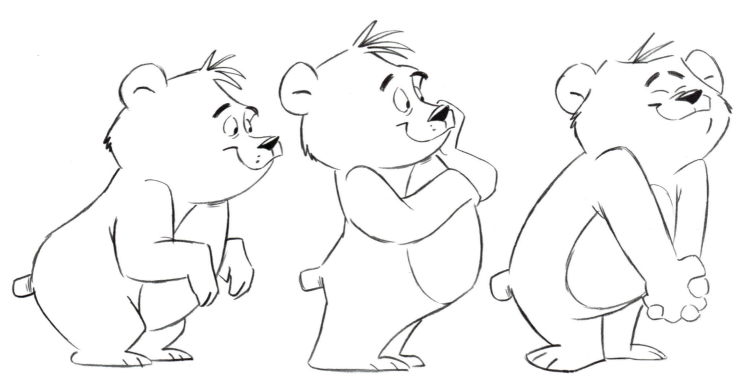

SUPPORTED EXPRESSIONS

In these three happy expressions, the body is as *involved* in expressing joy as the face. The result is a much more emphatic overall attitude of elation.

NOT SHOWING THE EFFECTS OF WEIGHT AND STRESS ON THE BODY

Weight affects how people walk and move. A fat man walks up the stairs differently from a thin man; he either leans backward or forward to counterbalance his massive girth. A person pushing a piano or carrying a backpack must also respond to the weight affecting him or her.

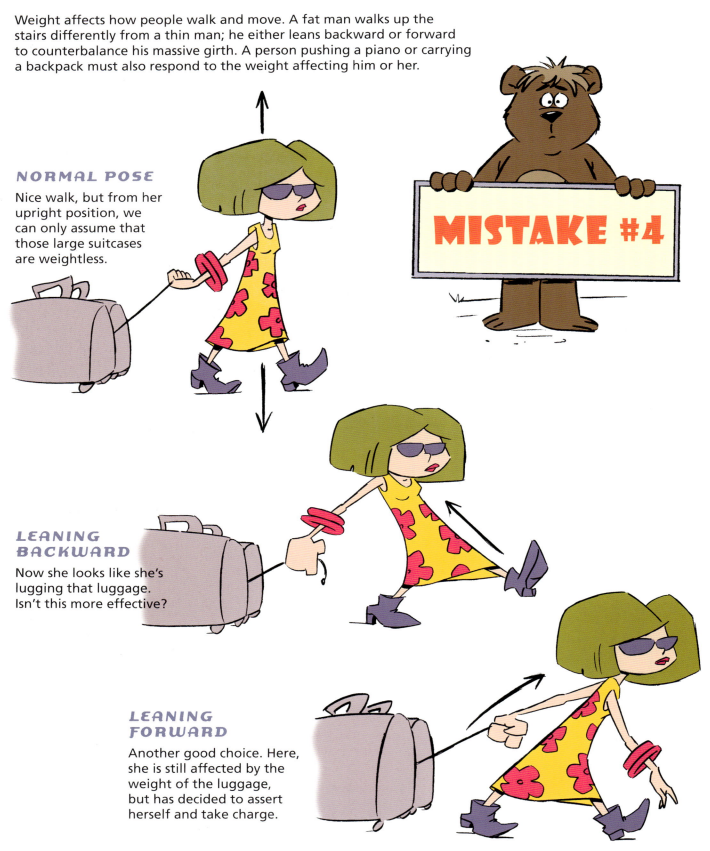

NORMAL POSE

Nice walk, but from her upright position, we can only assume that those large suitcases are weightless.

MISTAKE #4

LEANING BACKWARD

Now she looks like she's lugging that luggage. Isn't this more effective?

LEANING FORWARD

Another good choice. Here, she is still affected by the weight of the luggage, but has decided to assert herself and take charge.

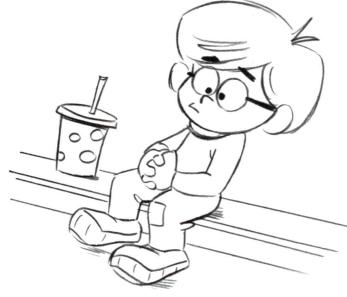

ABOUT TO FALL BACKWARDS

This mistake causes subconscious upset to the audience or reader. When a character is off balance, it's distracting and prevents the reader from sinking into the scene.

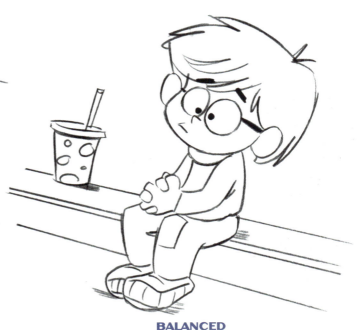

BALANCED

"EYEBALLING" YOUR POSE

Nothing fancy in spotting and correcting this basic mistake. You can simply "eyeball" your pose. If a character looks like he's going to tilt over unless you right him, make some adjustments.

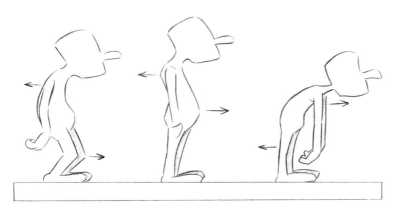

COMPENSATING

When one part of the body leans forward, another part must compensate by leaning backward; otherwise, the body will lean and fall. Note how these simplified figures are balanced by compensating forces that equal out.

MISTAKE #5
IS QUITE COMMON, AND CAN WRECK AN OTHERWISE GOOD DRAWING!

DRAWING FLAT, STIFF HAIR

Almost nothing detracts from a good character design as much as a poorly executed hairstyle. Hair should look natural, not stiff, and certainly not like a hair hat, as in these negative examples.

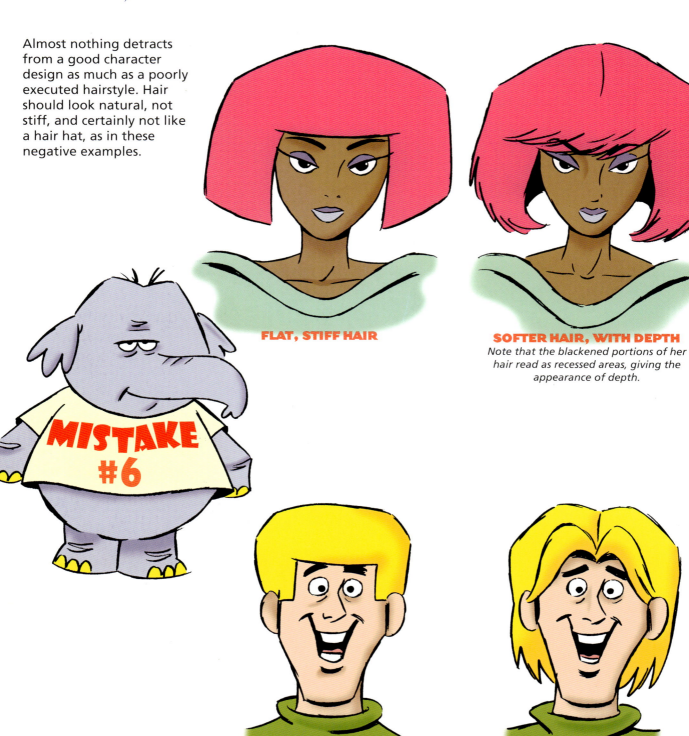

FLAT, STIFF HAIR

SOFTER HAIR, WITH DEPTH
Note that the blackened portions of her hair read as recessed areas, giving the appearance of depth.

FLAT, STIFF HAIR

SOFTER HAIR, WITH DEPTH
Note the three layers of hair: the waves that flap over the forehead (with shadows underneath them); the hair on the top of the head; and the shaggy hair behind the ears. These three layers also create the illusion of depth.

MISTAKE #6

MISTAKE #7

The better your drawing is, the bigger the temptation to keep noodling with it and "improving" it. This is an easy way to ruin a perfectly good cartoon. Don't overwork your drawings! Clean, simple, and straightforward is always the best approach for cartoonists.

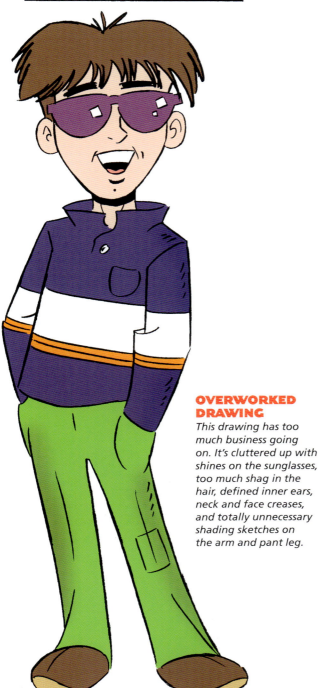

OVERWORKED DRAWING

This drawing has too much business going on. It's cluttered up with shines on the sunglasses, too much shag in the hair, defined inner ears, neck and face creases, and totally unnecessary shading sketches on the arm and pant leg.

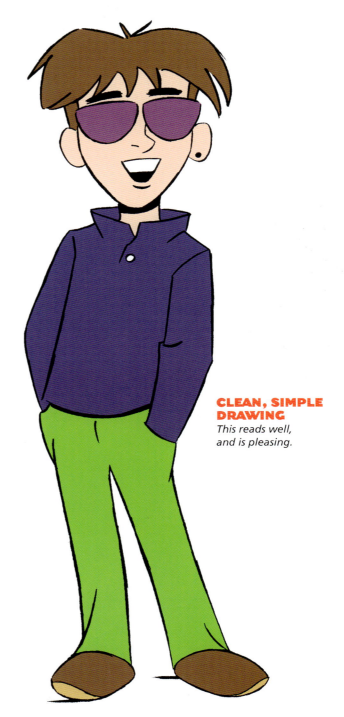

CLEAN, SIMPLE DRAWING

This reads well, and is pleasing.

FORGETTING ABOUT PERSPECTIVE

When you look at a scene, things that are closer to you look bigger, and things that are farther away look smaller. This concept is called *diminution.* What many people fail to realize is that this basic principle of perspective can be used to good effect to improve your drawings of the human figure as well as inanimate objects. Just *exaggerate* the size of the body parts that are closer to the viewer.

Foreshortening is another important principle of perspective. When you look at a long object or body part (like an arm or leg) that is pointing towards you, it appears shorter than it really is. If you draw it at its full length, the angle will be wrong. So you you have to "foreshorten" the object in your drawing.

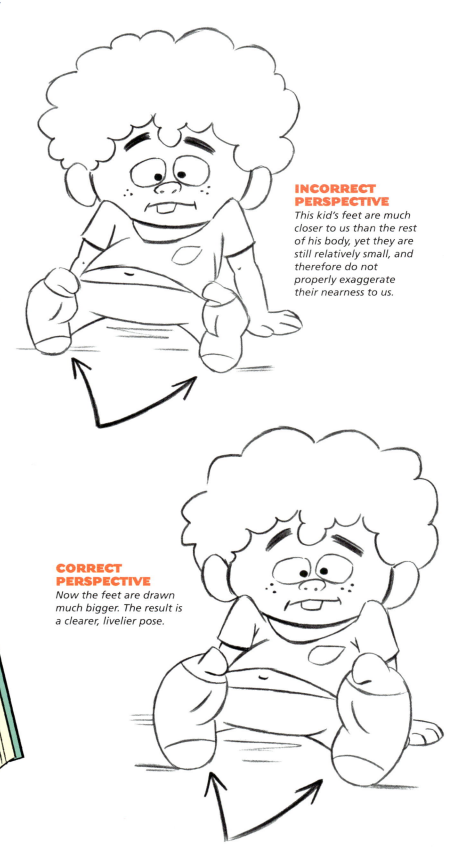

INCORRECT PERSPECTIVE
This kid's feet are much closer to us than the rest of his body, yet they are still relatively small, and therefore do not properly exaggerate their nearness to us.

CORRECT PERSPECTIVE
Now the feet are drawn much bigger. The result is a clearer, livelier pose.

MISTAKE #8

TOTAL FIGURE IN PERSPECTIVE

Sometimes a character is positioned in such a way that everything about him should be exaggerated. In the drawing on the last page, only the boy's feet stood out. But in this recumbent pose, the total length of the boy's body is traveling back, *away* from the reader. As a result, the boy's body looks compressed as he recedes into the distance (*foreshortening*), and seems to get "bigger" toward the foreground (*diminution*).

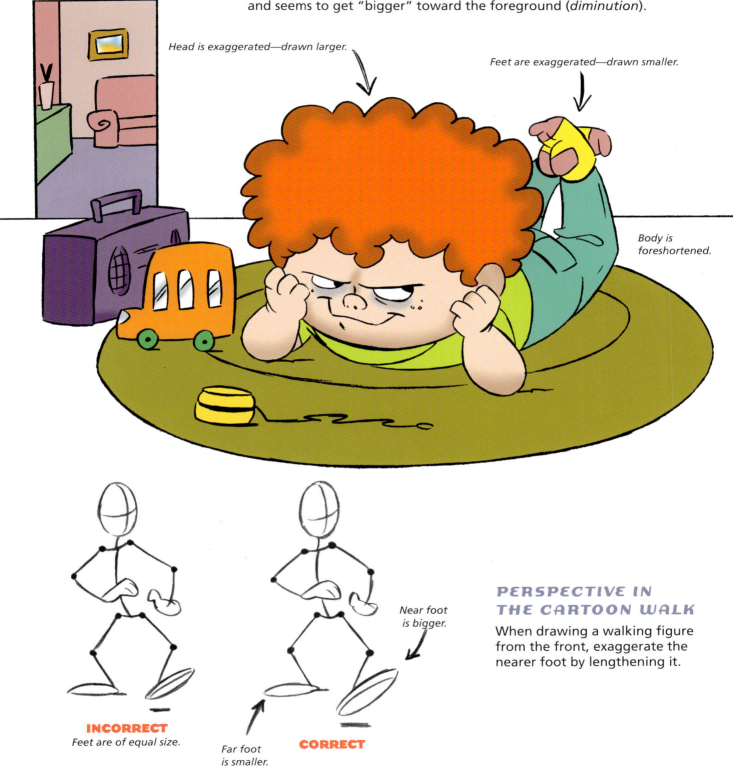

Head is exaggerated—drawn larger.

Feet are exaggerated—drawn smaller.

Body is foreshortened.

Near foot is bigger.

INCORRECT
Feet are of equal size.

Far foot is smaller.

CORRECT

PERSPECTIVE IN THE CARTOON WALK

When drawing a walking figure from the front, exaggerate the nearer foot by lengthening it.

DRAWINGS WITH NO THRUST OR INTENTION

If your character is going to move in a direction, make him *really* move. Cartoons are based on exaggeration, so their actions should always be larger than life.

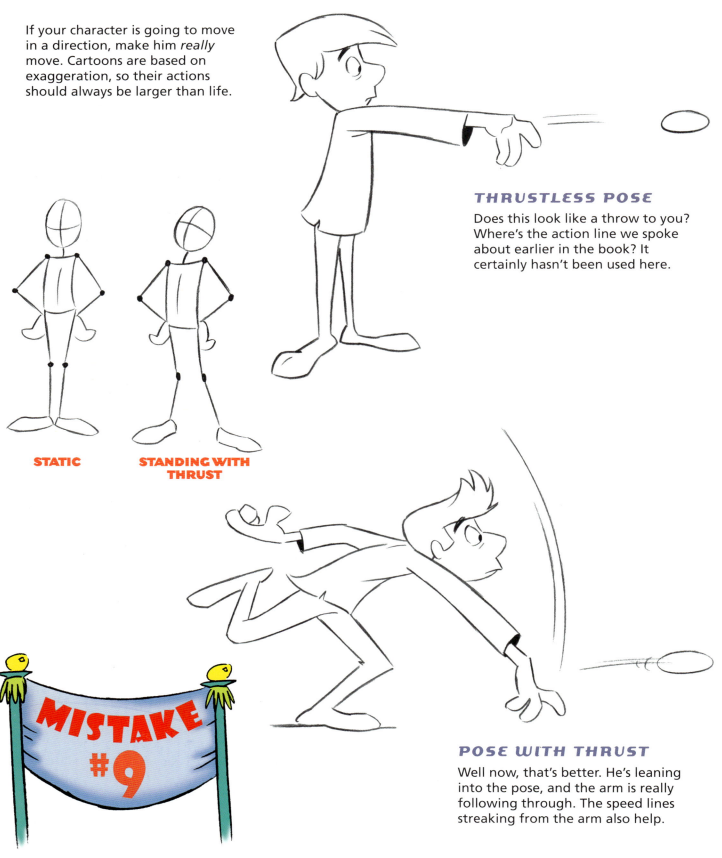

STATIC

STANDING WITH THRUST

THRUSTLESS POSE

Does this look like a throw to you? Where's the action line we spoke about earlier in the book? It certainly hasn't been used here.

MISTAKE #9

POSE WITH THRUST

Well now, that's better. He's leaning into the pose, and the arm is really following through. The speed lines streaking from the arm also help.

SPEED LINES

Too many smoke clouds.

Special effects, such as speed lines, beads of sweat, and motion lines add to the fun of cartooning. But if you overuse them, they will actually detract from your drawings. Always remember that it's the cartoon character himself who has to look like he's moving; the speed lines are only supportive devices. Focus your efforts on the *character* rather than the special effects. Too often, I've seen beginners draw someone running in a stiff pose with tons of speed lines all around him. Toss out most of the special effects and work harder on the pose.

One smoke cloud is sufficient to get across the idea of a quick getaway.

MOTION LINES

Never use motion lines *inside* the outline of the body. The paw over this dog's belly proves the point. Is it showing motion, or is it pushing on the shirt, thereby creating wrinkles in the fabric?

EXCESSIVE WORRY LINES

This guy has way too much going on! It would be better to cut down the worry lines by at least half, removing them from the shoulders and the top of the head, while leaving the ones beside his ears and jaw.

THE WORLD OF Cartoon Animals

So far, we've focused mainly on human characters, with a few animals tossed in here and there. But as anyone who loves cartoons will tell you, animals are *big-time* popular. They've been cast as heroes, comedians, adorable babies, and everything in between. Whether your personal interest is in animated movies, animated television shows, comic strips, electronic games, illustrated children's books, greeting cards, advertisements, or humorous illustration, animals are extremely well represented. They're fun to draw and always in demand. Let's try some. You're sure to discover that you have a knack for drawing a number of species!

ANIMALS ARE A PERSONAL FAVORITE . . .

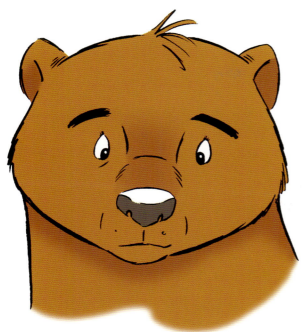

Animal heads vary greatly from one species to another. But most of them have one major thing in common that you should remember: long muzzles that must be severely foreshortened. The horse is an exception. It hangs its head low, with its muzzle pointed down, avoiding the foreshortening problem. When you foreshorten the muzzle of an animal (bear, dog, cat, lion, alligator, etc.) the most important thing to remember is to clearly draw the bridge of the nose—that's the short, curved line that goes just above the nose itself.

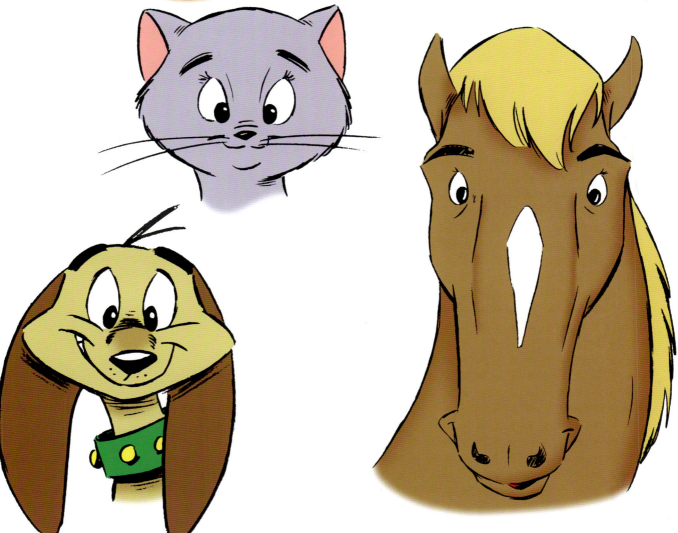

HEADS—SIDE VIEW

You can clearly see how long the muzzles of animals are in the side view. Some cartoon animals, such as the dog and kitten, have high foreheads, while some, like the horse, have very low ones. Still others, like the bear, have foreheads that fall somewhere in between. Note, too, the different ear shapes specific to each species.

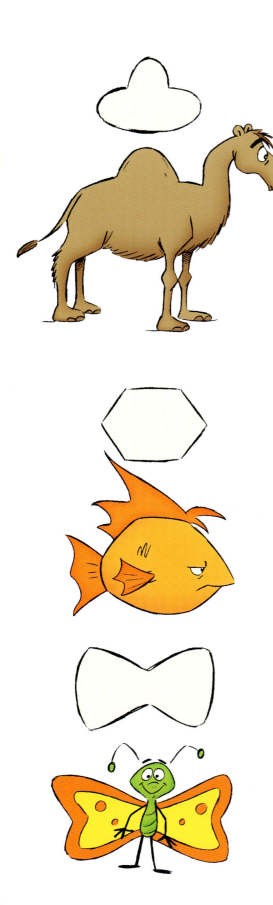

When drawing an animal's body, think in terms of overall shapes. In this way, you can simplify the form in your mind, which will make the execution much easier.

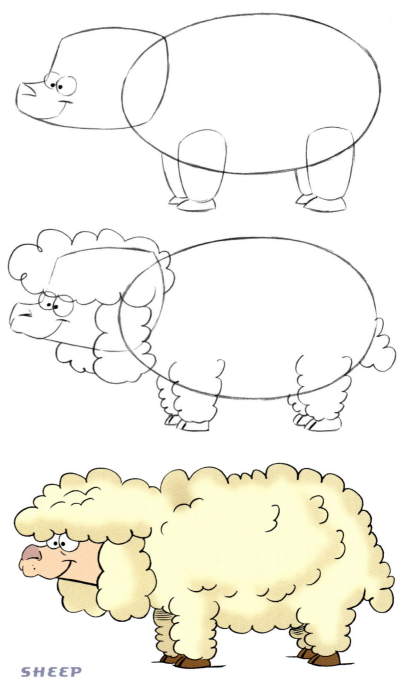

SHEEP

Here's a good example of an animal whose cartoon body has a very simple overall shape. A sheep is basically an oval-shaped ball of wool with a head, legs, and tail. Make the wool look fluffy by adding many small bumps. Don't draw it shaggy, or it'll look like fur.

RACCOON

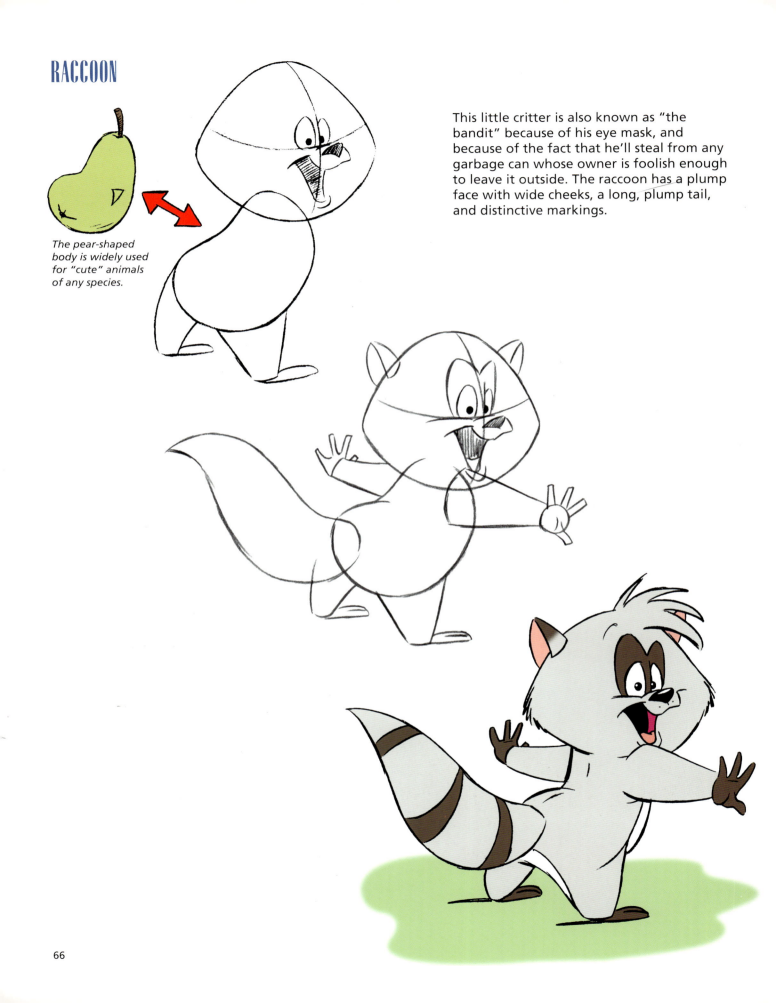

The pear-shaped body is widely used for "cute" animals of any species.

This little critter is also known as "the bandit" because of his eye mask, and because of the fact that he'll steal from any garbage can whose owner is foolish enough to leave it outside. The raccoon has a plump face with wide cheeks, a long, plump tail, and distinctive markings.

The tortoise's neck is skinny and wrinkled, with no muscle tone. The head can retract into its opening, which has a small protrusion underneath, like a shelf. The legs, which end in elephant-like feet, are not long, but they aren't stumpy either. Tortoises have high-backed shells. The turtle, the tortoise's water-based cousin, has a lower shell and webbed feet.

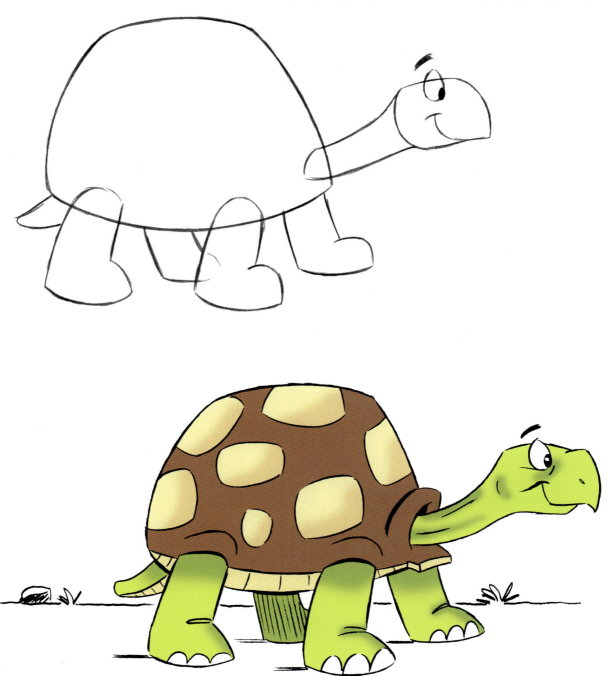

SHARK

The cartoon shark is a powerful beast, always sporting huge, sharp teeth and a prominent dorsal fin on its back. Its eyes should appear in the middle of its head, *not* toward the top of the forehead. It's got a big chest and a narrow tail, giving it a quite intimidating appearance. The tip of the nose should point up slightly.

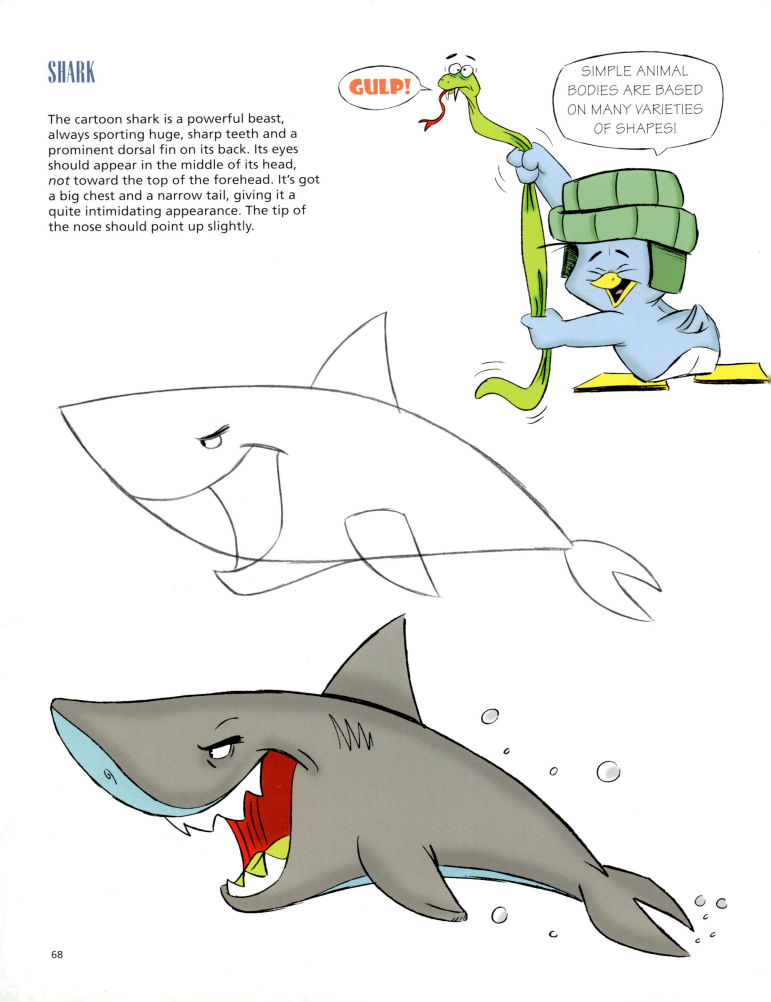

Penguins are such delightful, cheerful birds that they have become a favorite subject among cartoonists, including yours truly. You can represent their famous waddle by showing them swaying from side to side as they lift first one foot, then the other. Do not give your penguin a neck. He should have his head firmly planted on a squat little body. Although penguins have individual toes, cartoonists generally prefer to draw the feet as giant pads. The wings can be transformed into mitten-type hands by the cartoonist when the need arises.

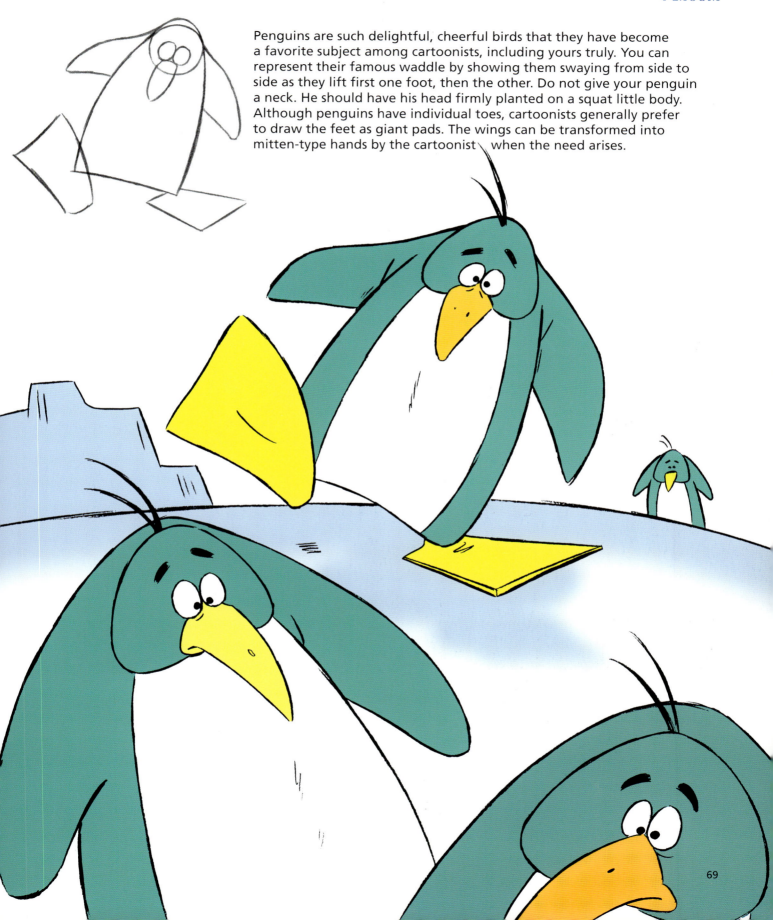

69

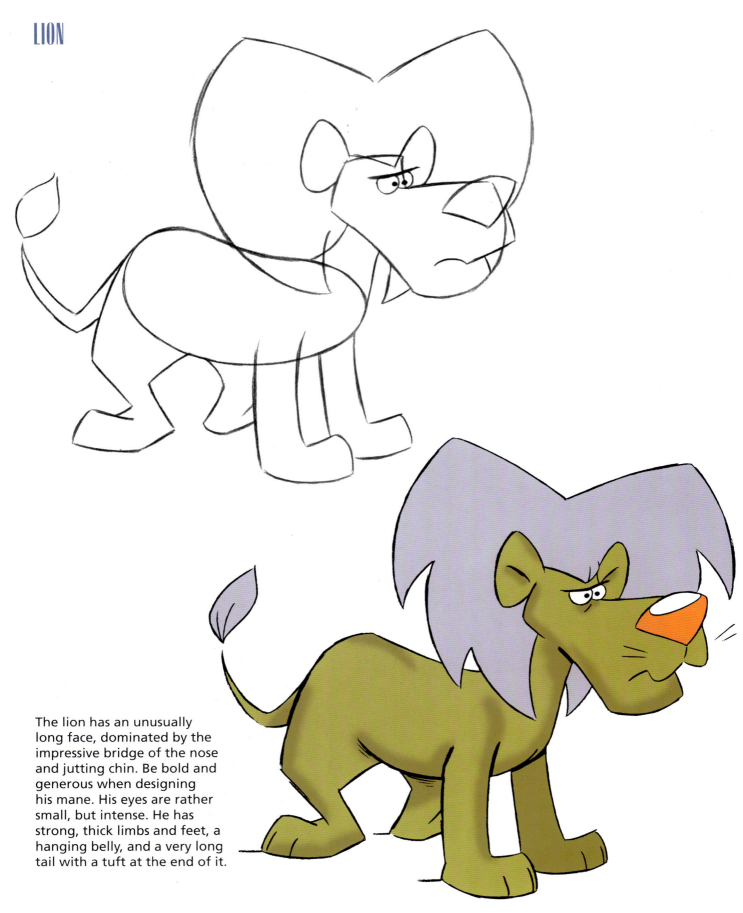

The lion has an unusually long face, dominated by the impressive bridge of the nose and jutting chin. Be bold and generous when designing his mane. His eyes are rather small, but intense. He has strong, thick limbs and feet, a hanging belly, and a very long tail with a tuft at the end of it.

The bull is the ultimate bully of the cartoon world. He is all chest and shoulders. His head hangs low, showing that he is ready to charge at a moment's notice. His forehead is thick and massive to hold the horns firmly in place. His nostrils are drawn large, to add to the sense that the bull is steaming mad. Turn the front legs inward to make him appear even more bulky and tough.

HOUSE CAT

The house cat is a fluffy ball of fun. Keep her plump, with basic shapes and soft curves—no hard angles. Tiny feet and a tiny nose give her a dainty, vain appearance. She should be well-groomed, not shaggy, because she is the ultimate spoiled pet.

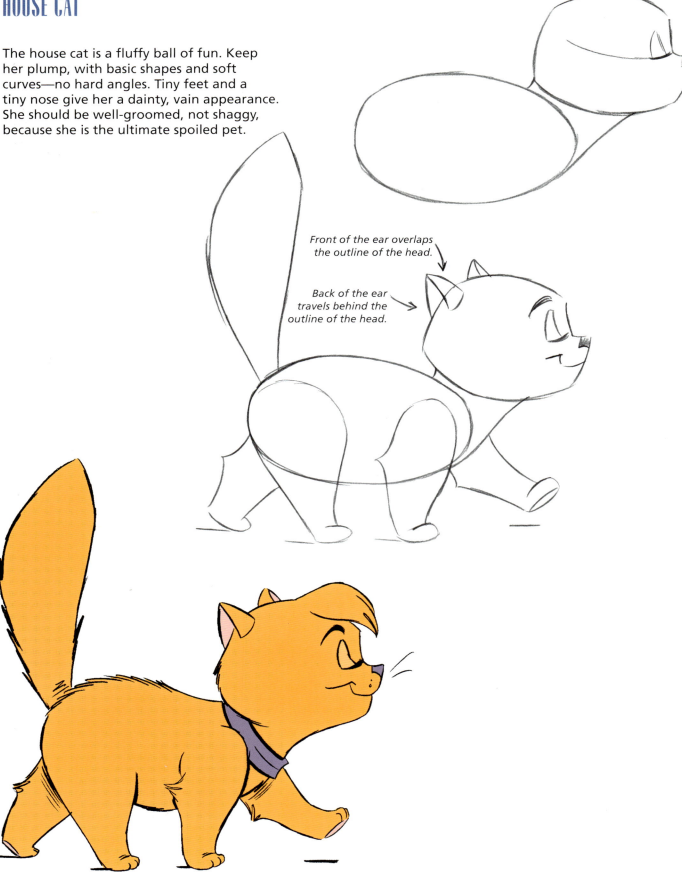

Front of the ear overlaps the outline of the head.

Back of the ear travels behind the outline of the head.

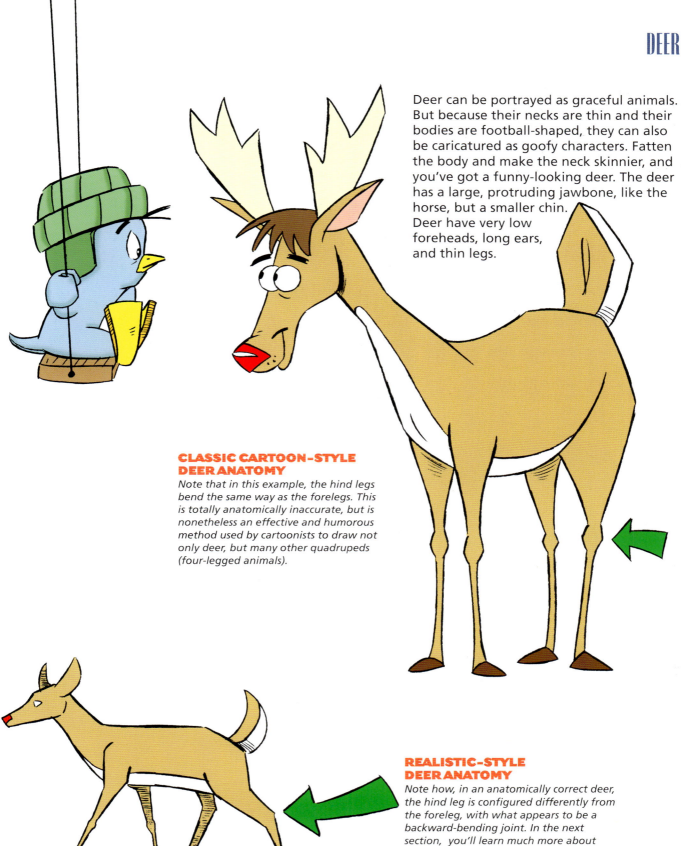

Deer can be portrayed as graceful animals. But because their necks are thin and their bodies are football-shaped, they can also be caricatured as goofy characters. Fatten the body and make the neck skinnier, and you've got a funny-looking deer. The deer has a large, protruding jawbone, like the horse, but a smaller chin. Deer have very low foreheads, long ears, and thin legs.

CLASSIC CARTOON-STYLE DEER ANATOMY

Note that in this example, the hind legs bend the same way as the forelegs. This is totally anatomically inaccurate, but is nonetheless an effective and humorous method used by cartoonists to draw not only deer, but many other quadrupeds (four-legged animals).

REALISTIC-STYLE DEER ANATOMY

Note how, in an anatomically correct deer, the hind leg is configured differently from the foreleg, with what appears to be a backward-bending joint. In the next section, you'll learn much more about drawing realistic-style animals!

REALISTIC-STYLE ANIMAL ANATOMY

Not all cartoons of animals are broad and rubbery. Some animal cartoons require a certain degree of understanding of the animal's anatomy. In animated feature films, the cartoon animals look more like real animals than, for example, Bugs Bunny resembles a true rabbit.

By this point, you should be comfortable enough with the principles of drawing to be able to easily keep up with this intermediate section. You may not be able to draw each animal perfectly the first time out, but if you try to understand the basic principles being discussed, that knowledge will almost certainly enhance your drawing ability as you continue to practice.

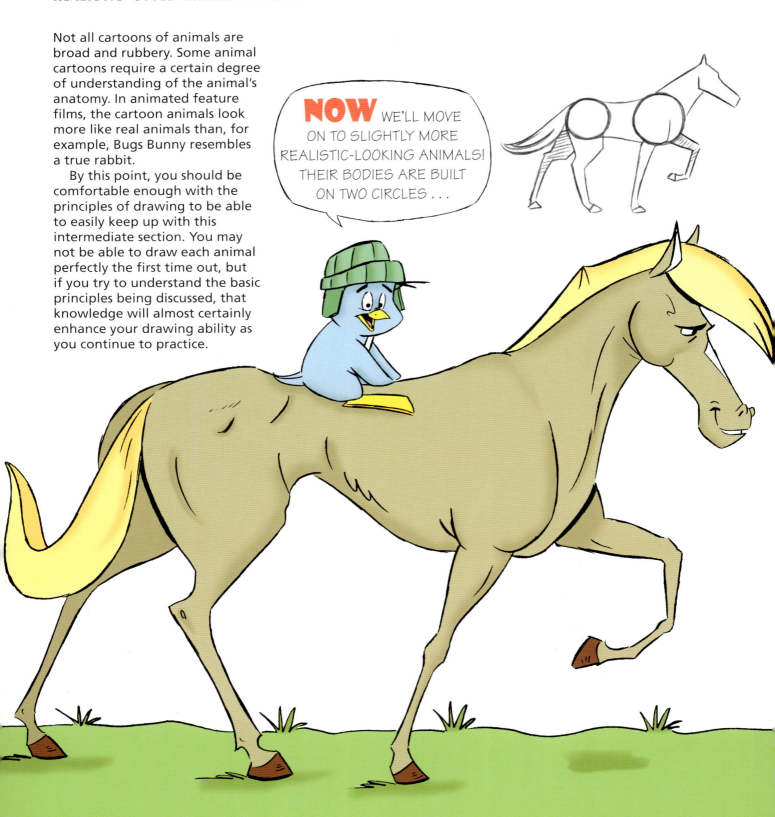

NOW WE'LL MOVE ON TO SLIGHTLY MORE REALISTIC-LOOKING ANIMALS! THEIR BODIES ARE BUILT ON TWO CIRCLES . . .

Start with two circles or ovals. These will represent the two major areas: the chest and the hindquarters. Dividing the body into two joined shapes will make it look more realistic than if we based it on one simple shape.

I use the dog as the basis for understanding how four-legged creatures are built because we are all familiar with dogs. Once we understand why the dog's body is built the way it is, we can take that information and use it to understand other, less-familiar four-legged creatures.

Here is a simplified version of the joints of the forelegs and hind legs of the dog. Note the forward-tilting shoulder blade just below the base of the dog's neck. Also note how the pelvis slopes off toward the tail.

Sketching in the bones every time you draw an animal is a lot of work, and it's not necessary once you are able to visualize the skeletal structure and use it to inform your drawing. At that point, you can skip to the step pictured here. In this stage, the legs and forearms are drawn as large sections that indicate the bones without including the skeletal details that would have been erased from the completed drawing anyway.

Building on the previous step, here is the finished dog. You can't draw the limbs correctly if you don't understand where the joints are. That's why the earlier steps are so useful.

UNDERSTANDING HOW THE HORSE IS BUILT

You're in for a pleasant surprise; the process of drawing the horse is surprisingly similar to the way we just drew the dog! If you learn how to draw the dog in a "realistic" cartoon fashion, you will already be more than halfway to drawing the horse.

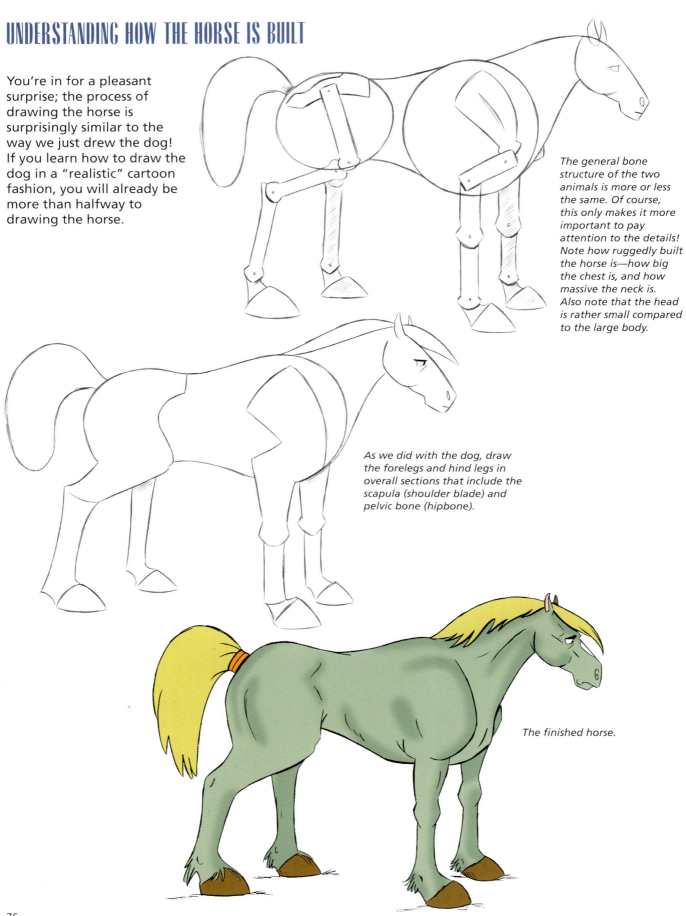

The general bone structure of the two animals is more or less the same. Of course, this only makes it more important to pay attention to the details! Note how ruggedly built the horse is—how big the chest is, and how massive the neck is. Also note that the head is rather small compared to the large body.

As we did with the dog, draw the forelegs and hind legs in overall sections that include the scapula (shoulder blade) and pelvic bone (hipbone).

The finished horse.

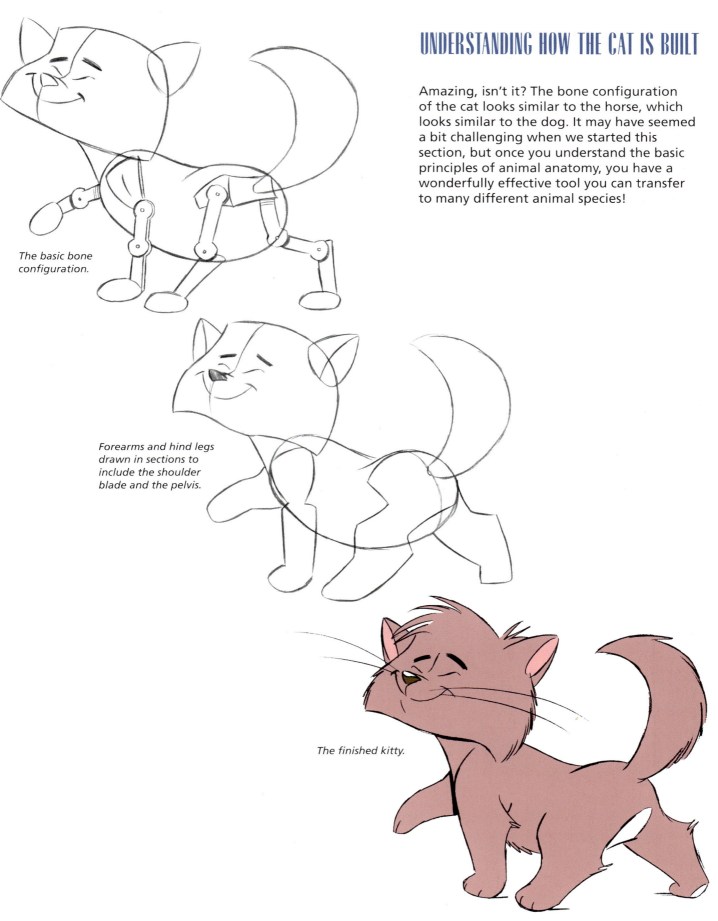

UNDERSTANDING HOW THE CAT IS BUILT

Amazing, isn't it? The bone configuration of the cat looks similar to the horse, which looks similar to the dog. It may have seemed a bit challenging when we started this section, but once you understand the basic principles of animal anatomy, you have a wonderfully effective tool you can transfer to many different animal species!

The basic bone configuration.

Forearms and hind legs drawn in sections to include the shoulder blade and the pelvis.

The finished kitty.

CAPE BUFFALO

This African buffalo is a gentle giant. It has a very large nose and horns that go completely across the top of its head. The body is thick throughout, without even a hint of a waistline; therefore, we can draw the torso as a single, simple shape, yet still borrow some elements from our newfound knowledge of animal anatomy. Note the large curve of the shoulder area and the downward slant of the pelvic region.

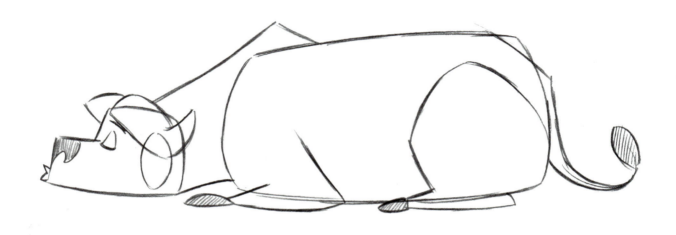

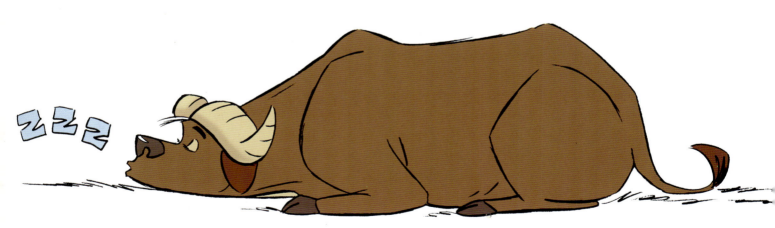

Swift and agile, the gazelle has thin
legs and small hooves. It has to. Every
predator looks at it as a potential meal.
Its identifying characteristics are its ridged
horns, deer-like face, compact body and
short tail with a shaggy tuft at the end.

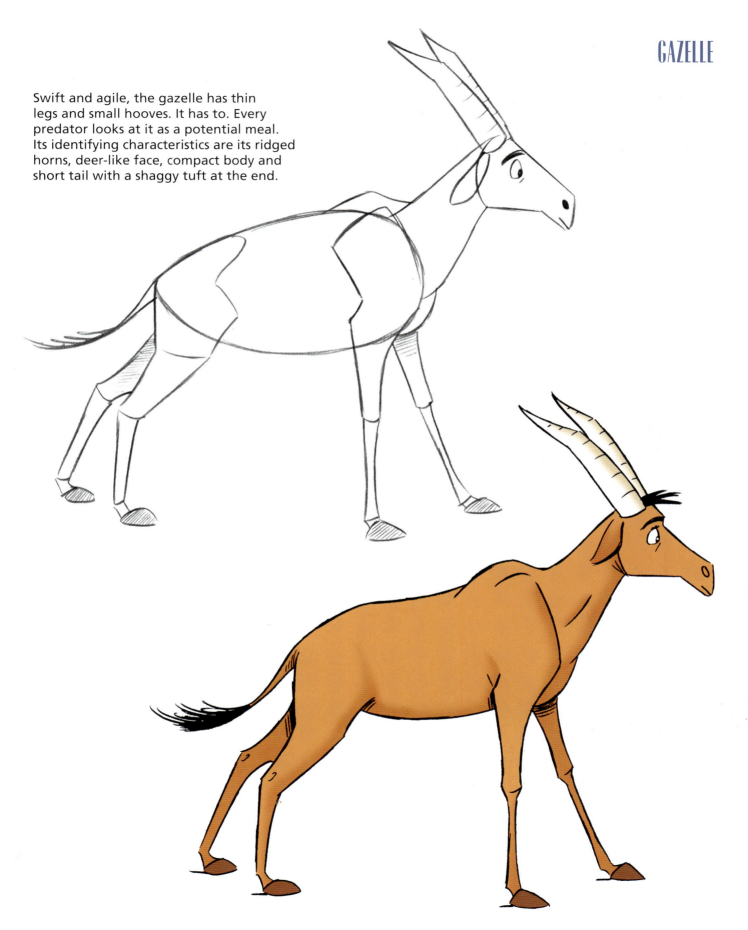

WOLF

The wolf should always look skinny and scruffy, like a hungry predator who's ready to attack. Cartoon wolves have very long ears, unlike real wolves, whose ears are of medium size. The eyes should be narrow, which translates to "evil" in the cartoon world. Note the visible fangs, which remind us that this is a wild animal and not a domesticated dog, which would be drawn with short, neat rows of teeth. A big bushy tail also adds to the feral appearance of the cartoon wolf.

Yep, it's the fastest land animal on earth. At a sprint, it can reach up to 70 miles per hour, but it can only keep that speed up for a few seconds. It's not a long distance runner. The cheetah is built for speed. It has long, thin legs, which are heavily muscled at the shoulders and upper thigh area. The chest is quite large, but the waist is incredibly thin. The head is rather small, much smaller in contrast to the body than the lion's or the tiger's. The high vertebrae along the upper region of the back give the cheetah that characteristic high "bump" above his shoulders (right between his neck and his back).

THE EXCEPTIONS TO THE RULE

All of the animals we have drawn so far in the realistic style have had hind legs that appear to bend *backward.* But there are two important and popular animals that should be drawn with "normal" hind legs: the bear and the elephant.

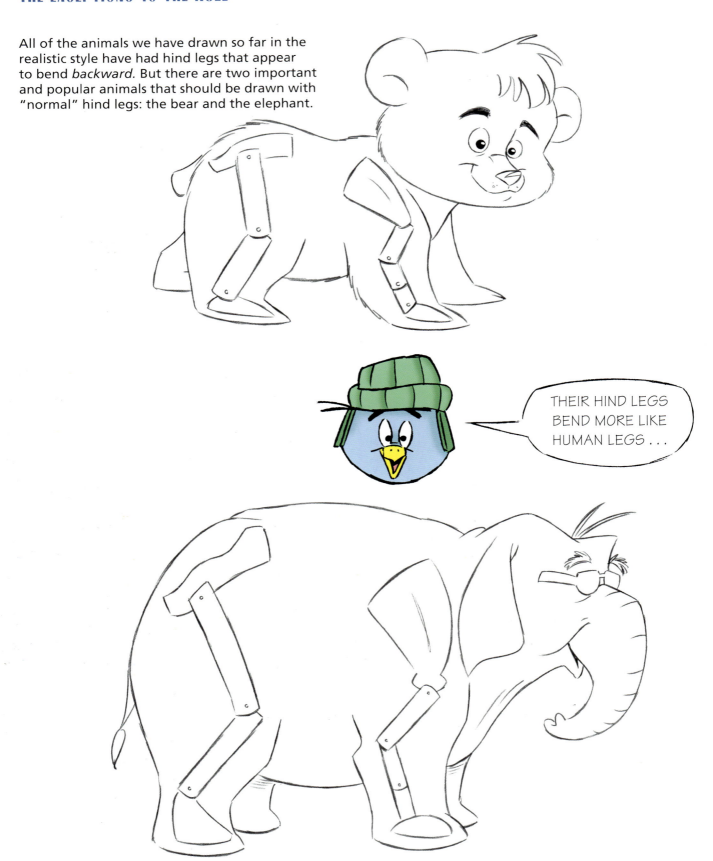

THEIR HIND LEGS BEND MORE LIKE HUMAN LEGS . . .

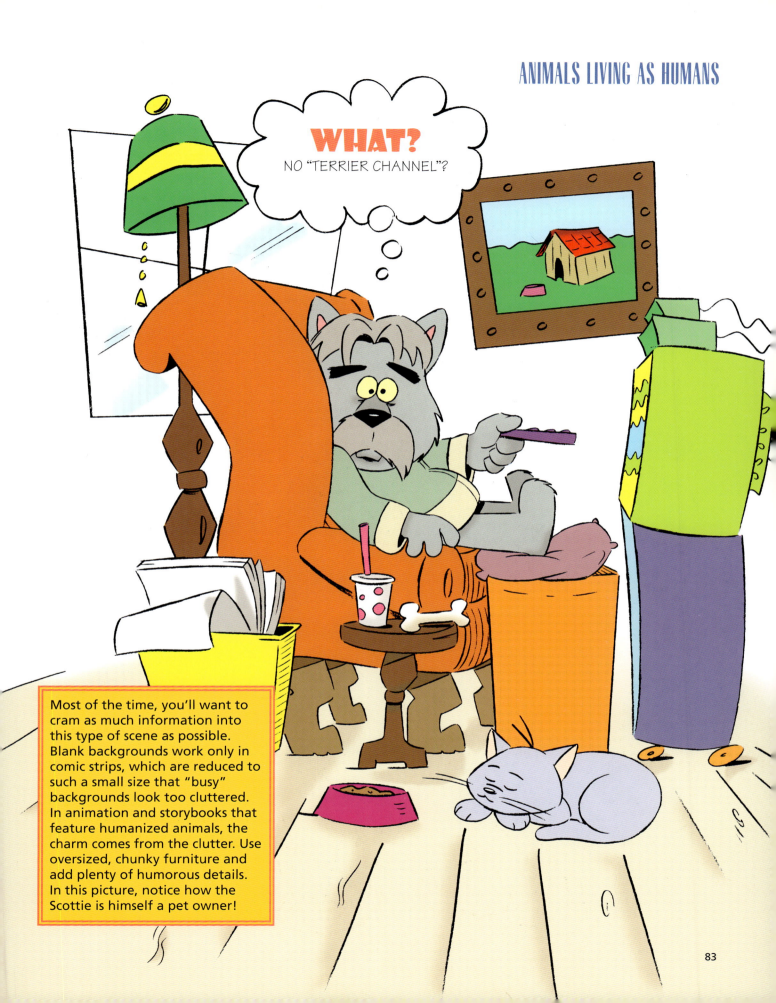

Most of the time, you'll want to cram as much information into this type of scene as possible. Blank backgrounds work only in comic strips, which are reduced to such a small size that "busy" backgrounds look too cluttered. In animation and storybooks that feature humanized animals, the charm comes from the clutter. Use oversized, chunky furniture and add plenty of humorous details. In this picture, notice how the Scottie is himself a pet owner!

THE MAGIC OF Animation

I LOVE ANIMATED MOVIES!

Animation is quite an old art form. It was invented at the end of the 19th century, very soon after the first live-action movies were made. It has proven to be endlessly appealing and offers many opportunities for cartoonists to earn a handsome living from their talents.

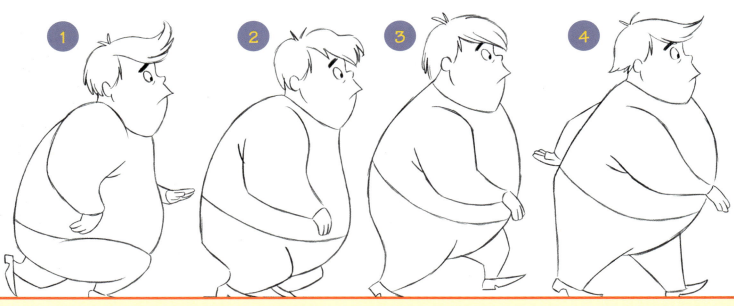

1 Notice that the arms and legs are always in motion. This is the recoil step, where the character appears at his lowest height in the walk.

2 Character starts to rise up a bit. This is the crossover step, where the character's left leg crosses in front of his right.

3 This is the push-off drawing, where the character's back leg thrusts him forward. This is where the character appears the tallest.

4 This is the contact step, when both feet are firmly on the ground.

An *animation cycle* is a series of drawings that can be repeated continuously to represent a repetitive motion. Using a cycle saves time, because it means that the artist doesn't have to draw dozens of drawings that are virtually identical to each other. This is an eight-drawing walk cycle. It goes from drawing 1 to drawing 8, then begins again with drawing 1. Drawings called *inbetweens* can be added to slow down and smooth out the action.

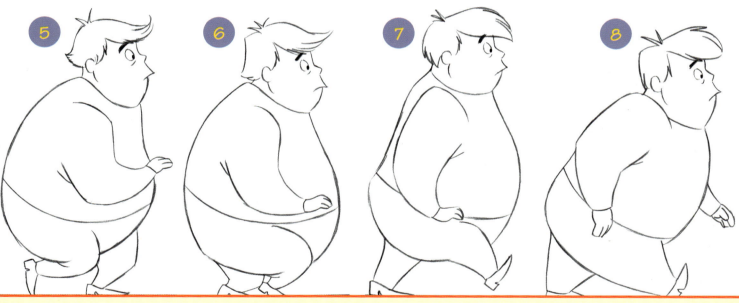

Character dips as he lifts his right leg and starts to bring it forward. This is the low point in the character's height.

This is another crossover step, where the character's right leg crosses in front of his left.

The push-off step again.

The contact step. Repeat cycle.

Don't forget about this chart! In addition to helping you to understand the general process of animation, it will serve as a valuable reference when you are trying to depict this specific action. Next time you need to draw a character walking, whether it's for animation or a comic strip, you'll have a greater selection of poses from which to choose.

THE CARTOON RUN

When animals run, their forelegs and hind legs are not the only body parts that are constantly in motion. Floppy ears and tails also move continuously, following the main action a beat behind. These delayed movements are called *secondary action.*

It may help to think of secondary action as the body's reaction to the main action. As you can see, the body does not remain upright during a run, but instead continually adjusts to the movements.

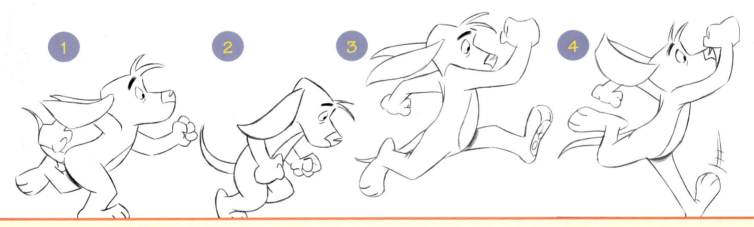

Arms far from the body, ears dragging, and tail back. The dog has just landed on his right foot.

He recoils, dips, and bends forward to anticipate the next drawing, in which he will use that coiled-up energy to spring forward.

He leaps into the air, both feet off the ground. His body is upright, but his tail dips down, dragging a beat behind the body. This is the character's tallest point in the run.

As he lands, his head tilts back, following a beat behind the body. Now the tail starts to come up, also still a beat behind what the body is doing. Same with the ears. The body is going down, but the tail and the ears are going up.

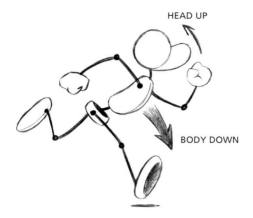

HEAD UP

BODY DOWN

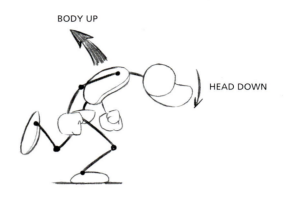

BODY UP

HEAD DOWN

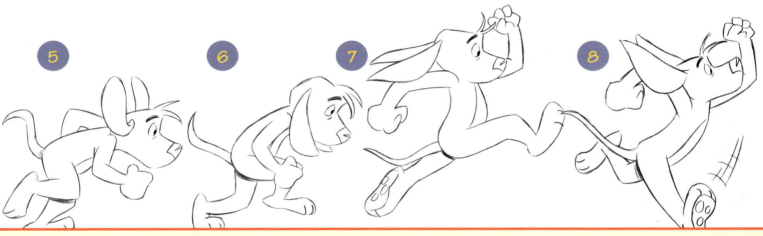

⑤ He sinks onto his bent knee. This is the second point of the run where the character is at his shortest height. The other was in drawing 2.

⑥ He leans forward, starting to push off for the big stride. As he rises, his ears and tail sink (secondary action).

⑦ He leaps into the air, his ears and tail lagging behind and dragging downward.

⑧ As he lands, his head flops back and his ears and tail fly up again. Repeat cycle.

THE FAST RUN

When a character runs very quickly, so much is going on at one time that you can't draw the arms swinging back and forth because they would seem to be flailing about. Instead, simplify the action by keeping the arms in one position. In addition, instead of making the character appear to bounce up and down by varying his height, you can cheat a little and keep him at the same height. This run is on a five-drawing cycle—fewer drawings than the walk because the action is faster.

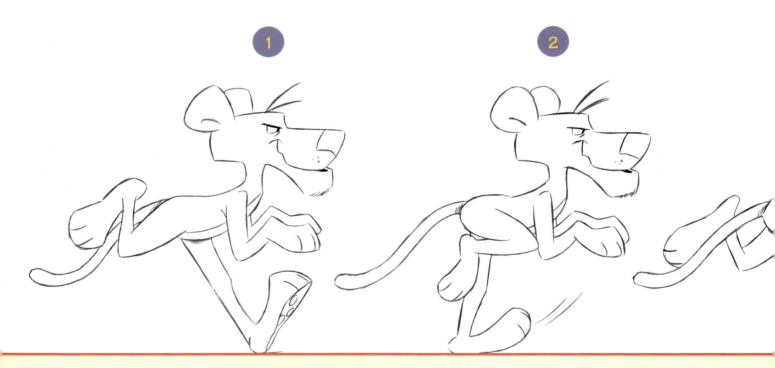

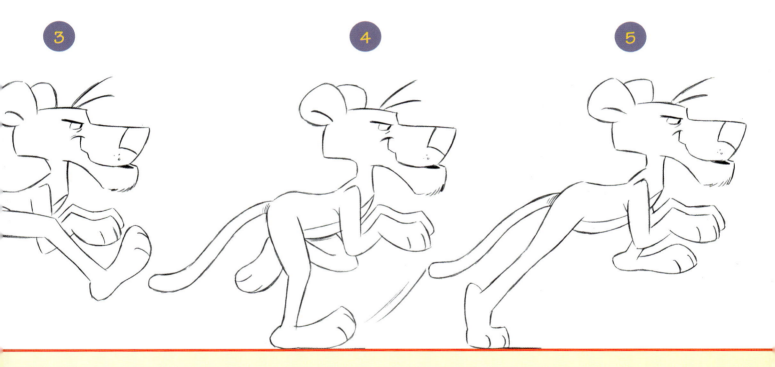

THE BASIC PRINCIPLES OF ANIMATION

Even if you don't think you want to be an animator, you should find this section useful. Cartoonists of all stripes, including those who work on comic strips and comic books, use the principles of animation every day because they relate to *motion* and *action.* Unless you plan to draw everything standing still, you will benefit from a few basic animation pointers.

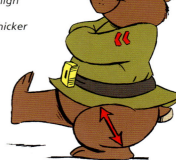

As he squats, the bear's thigh compresses, becoming thicker (squash).

SQUASH AND STRETCH

These related concepts become indispensable when you draw a cartoon character in motion. Imagine a balloon held between two hands. If it's compressed *(squashed)*, it gets fatter. If the balloon is pulled from both ends *(stretched),* it gets longer and thinner. The same is true for parts of the body.

ARMS FATTEN WHEN BENT...

Stretch is usually either a response to outside forces or the expression of an attitude. Without it, cartoons would look stiff and inflexible.

ATTITUDE
This happy cat is pleased that he's procured his next meal (although the mouse may have other ideas!). His posture pushes his chest out, and as a result, stretches his midsection, making his body attitude more intense.

RESPONSE TO OUTSIDE FORCES
Here, the extreme velocity of the rocket—an outside force—makes the cat's body stretch in two directions.

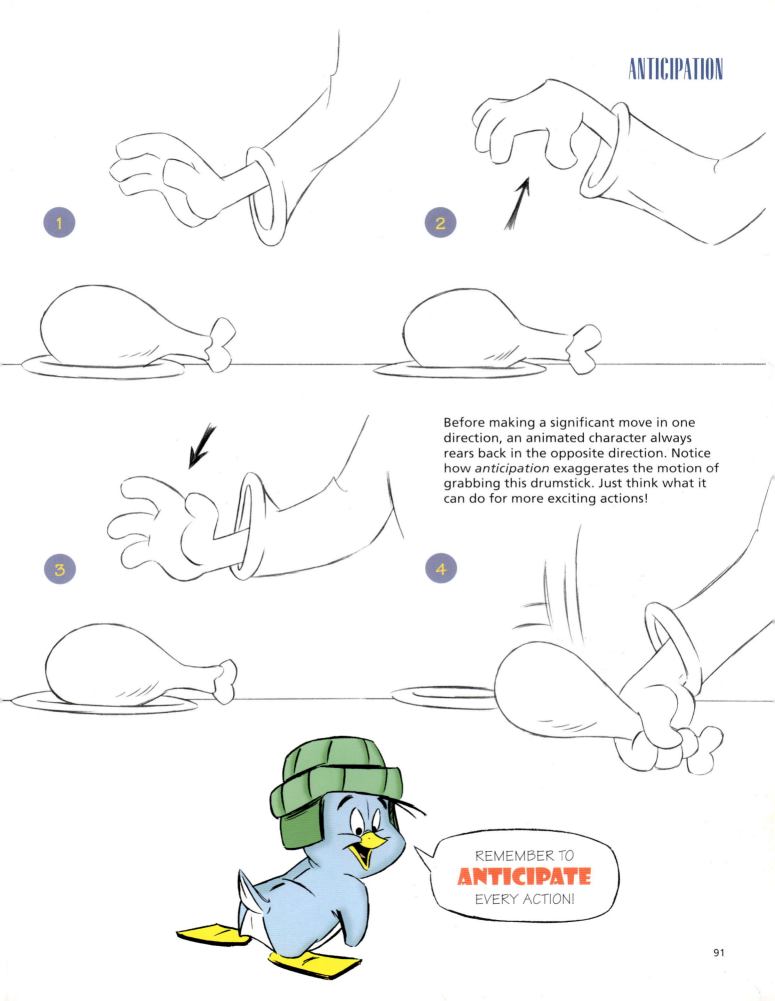

Before making a significant move in one direction, an animated character always rears back in the opposite direction. Notice how *anticipation* exaggerates the motion of grabbing this drumstick. Just think what it can do for more exciting actions!

REMEMBER TO **ANTICIPATE** EVERY ACTION!

THE JUMP

The jump exemplifies many important principles of animation in one movement: anticipation, squash and stretch, regrouping, and more.

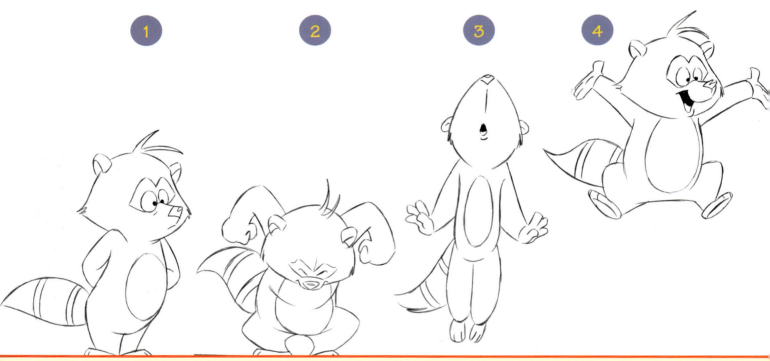

1 Little raccoon sees something good.

2 He prepares to jump in delight, but first anticipates the jump by scrunching his body (moving in the opposite direction of the jump: downward).

3 He jumps up, stretching as he goes.

4 He regains his form, regrouping in midair, as only a cartoon character can.

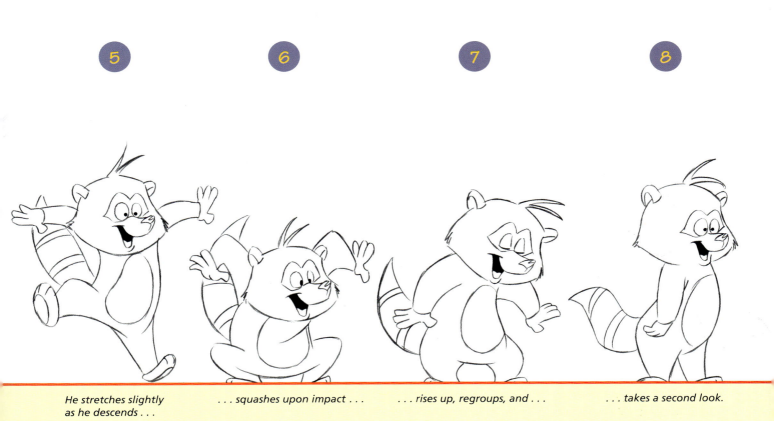

5

6

7

8

He stretches slightly
as he descends . . .

. . . squashes upon impact . . .

. . . rises up, regroups, and . . .

. . . takes a second look.

THE CARTOON "TAKE"

The take is a severe reaction—usually a very funny one. It is similar in execution to the jump, which we just learned. Do not use restraint when drawing the "take"—go as broad as possible.

Keep in mind that immediately following the "take" reaction, the character must quickly regain its original form.

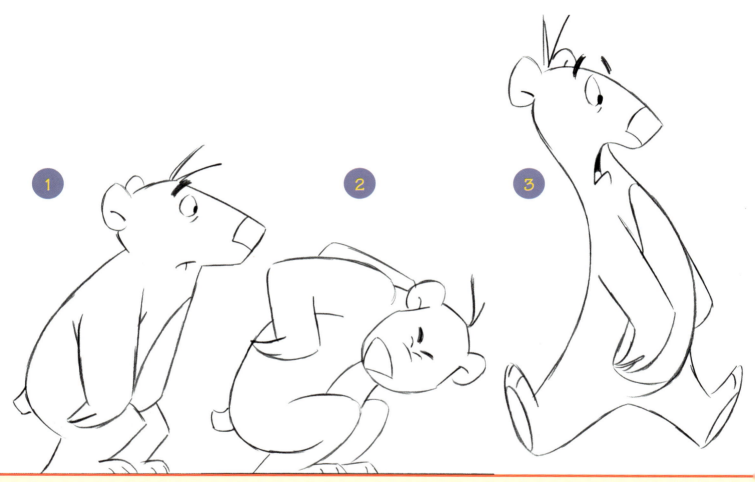

1

Our bear sees something amiss.

2

He anticipates the "take" by scrunching down and coiling (squash) . . .

3

. . . stretches into a wild take . . .

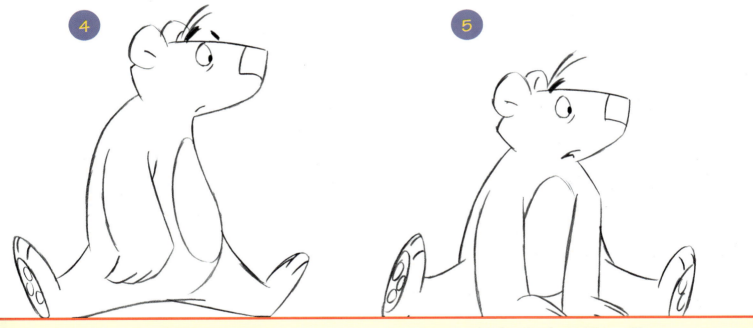

. . . *regains his form as he settles down . . .*

. . . *and ends up in a funny sitting position.*

Perspective
MADE SIMPLE

Without understanding the fundamentals of perspective, we can't accurately draw the world around us, or the world our cartoon characters live in. To place our characters somewhere, we have to draw a *background,* and that requires perspective. Perspective will help you to figure out where to place people on the page and how tall they should be relative to each other.

Let's say you want to draw two characters of the same height. Let's also suppose you want to place one character in the foreground and the other in the background. How do you draw that so it looks like there's lots of distance between them, rather than one of them appearing huge and the other tiny? We'll demystify this in a simple, straightforward manner that's amazingly easy to understand.

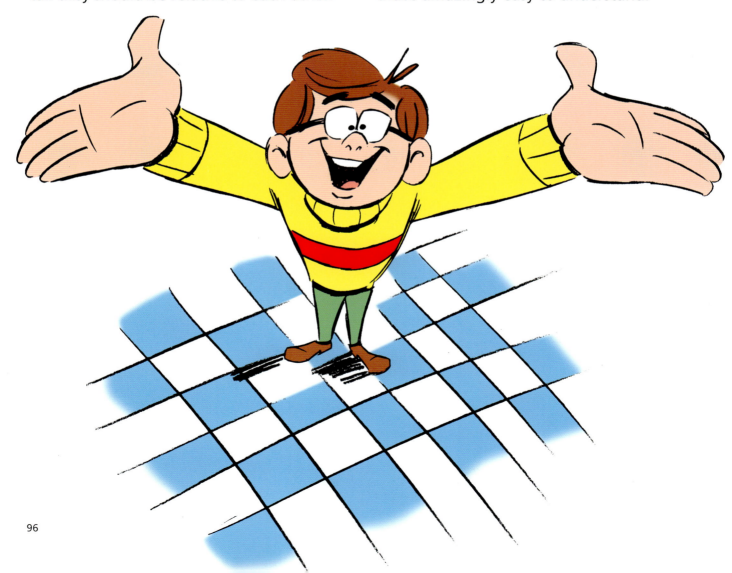

ONE-POINT PERSPECTIVE

Since not all objects have parallel sides—or any sides at all—you may find it helpful to think of whatever object you are trying to draw as a box. When two sides of the box are parallel to the horizon line (i.e., a flat side is facing you), you are dealing with *one-point perspective*. Most comic strip scenes use one-point perspective.

Notice the small star resting on the horizon line. The star represents the *vanishing point*. To keep everything you draw in perspective, every line that travels toward the horizon line in the distance—that is, every line that isn't perfectly vertical or horizontal—must converge at the vanishing point.

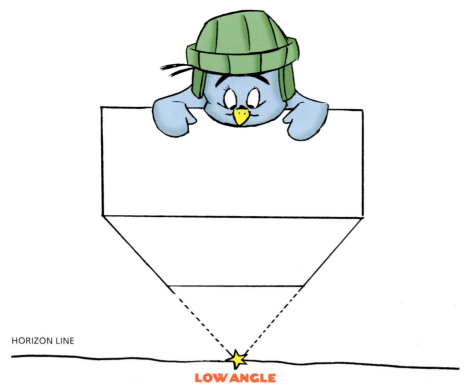

HORIZON LINE

LOW ANGLE
When the horizon line is below the box, we feel as though we are below the box, looking up at it. We can see the bottom of the box.

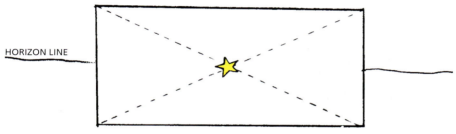

HORIZON LINE

DIRECTLY ON THE HORIZON LINE
When the box is centered on the horizon line, we feel as though it is exactly at eye level. Only one of its sides is visible.

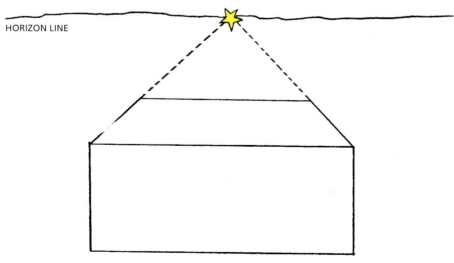

HORIZON LINE

HIGH ANGLE
When the horizon line is above the box, we feel as though we are above the box, looking down at it. We can see the top of the box.

LEARNING TO RECOGNIZE THE HORIZON LINE

Seeing is as big a part of art as drawing. If you can observe it, you can recreate it. Train yourself to see the horizon line when you're looking at a street, a hillside, the ocean, or any other scene.

The horizon line can typically be found where the sky meets the ground.

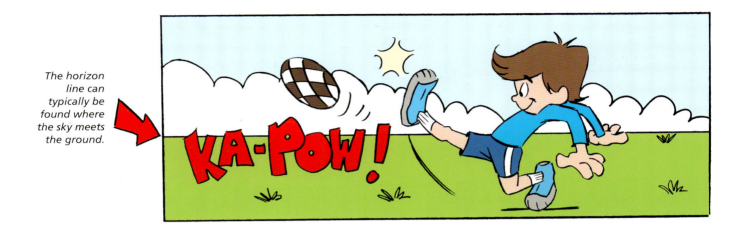

Sea level is always a good indicator when there's water around.

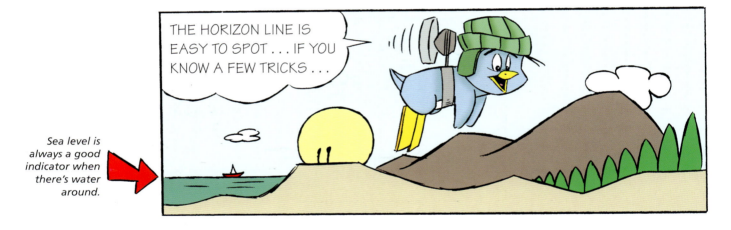

If you can't see any sky, look for the horizon line where the buildings meet the ground.

You can adjust the height of the horizon line to produce a variety of subtle effects on the viewer.

Horizon line in the middle gives a feeling of balance and stability.

Low horizon line gives the scene an open feeling.

High horizon line gives the scene a flat feeling, and makes us focus on what's going on in the foreground.

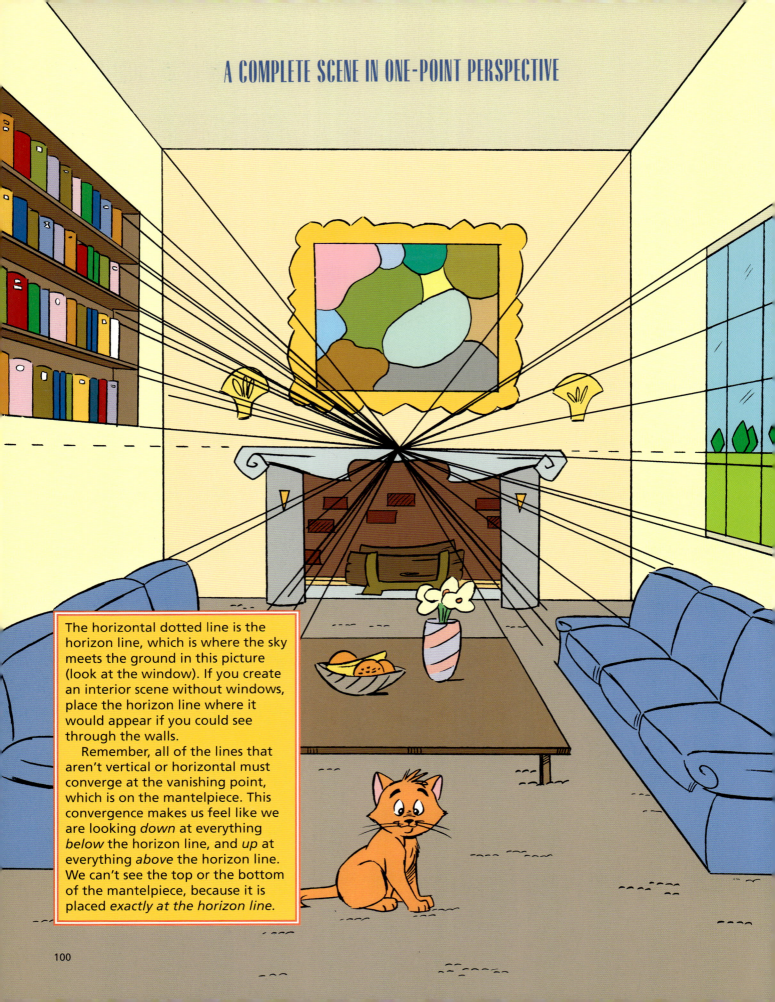

The horizontal dotted line is the horizon line, which is where the sky meets the ground in this picture (look at the window). If you create an interior scene without windows, place the horizon line where it would appear if you could see through the walls.

Remember, all of the lines that aren't vertical or horizontal must converge at the vanishing point, which is on the mantelpiece. This convergence makes us feel like we are looking *down* at everything *below* the horizon line, and *up* at everything *above* the horizon line. We can't see the top or the bottom of the mantelpiece, because it is placed *exactly at the horizon line*.

TWO-POINT PERSPECTIVE

When the corner of an object faces you, you can no longer draw it using one-point perspective. Instead, you should use *two-point perspective.* In this diagram, the box is placed at an angle, so the lines along the top and bottom of each side, which were horizontal in one-point perspective, appear to slant. Since the two sides slant in different directions, we need two vanishing points.

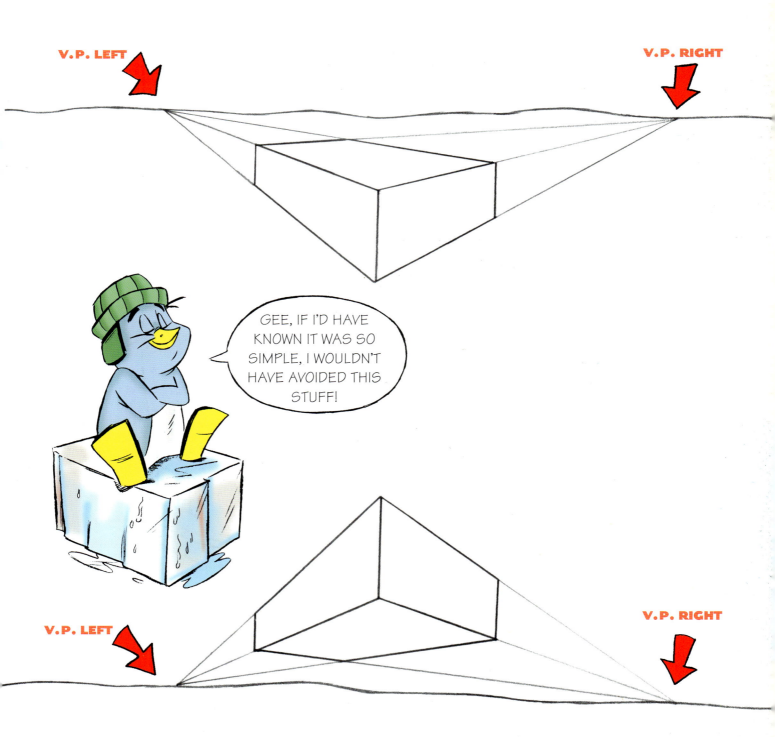

V.P. LEFT

V.P. RIGHT

GEE, IF I'D HAVE KNOWN IT WAS SO SIMPLE, I WOULDN'T HAVE AVOIDED THIS STUFF!

V.P. LEFT

V.P. RIGHT

DRAWING A CARTOON HOUSE USING TWO-POINT PERSPECTIVE

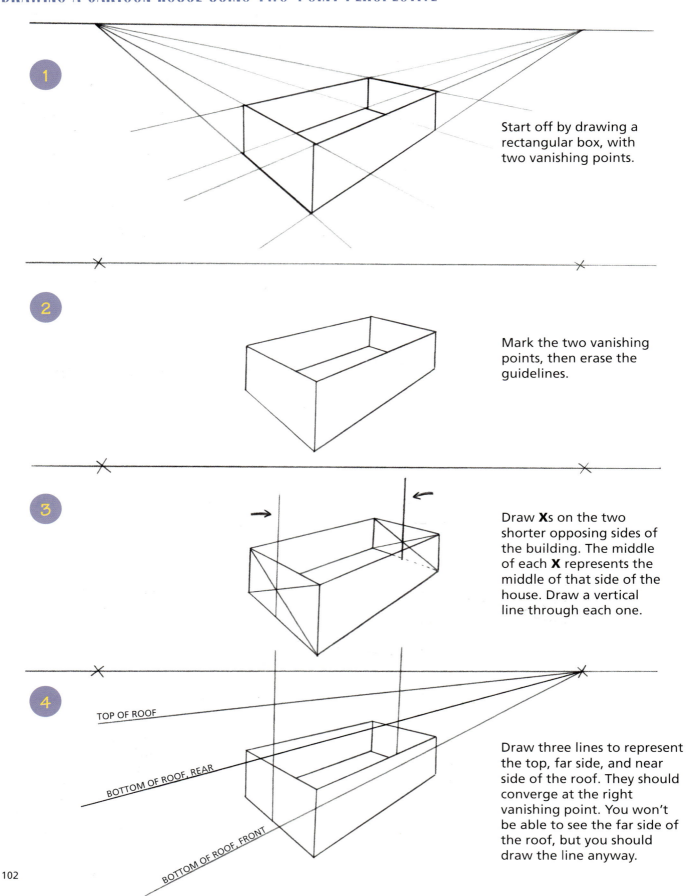

1 Start off by drawing a rectangular box, with two vanishing points.

2 Mark the two vanishing points, then erase the guidelines.

3 Draw **X**s on the two shorter opposing sides of the building. The middle of each **X** represents the middle of that side of the house. Draw a vertical line through each one.

TOP OF ROOF

BOTTOM OF ROOF, REAR

BOTTOM OF ROOF, FRONT

4 Draw three lines to represent the top, far side, and near side of the roof. They should converge at the right vanishing point. You won't be able to see the far side of the roof, but you should draw the line anyway.

5

Draw three lines from the top of the roof down past the top corners of the rectangle. (Skip the far back corner.) Now it's starting to look like a house!

6

Erase the guidelines. The house is starting to look pretty solid.

7

Using the previous drawing as a model for our proportions, you can soften the horizon line with a few gentle hills, and caricature the house to make it look cartoonier.

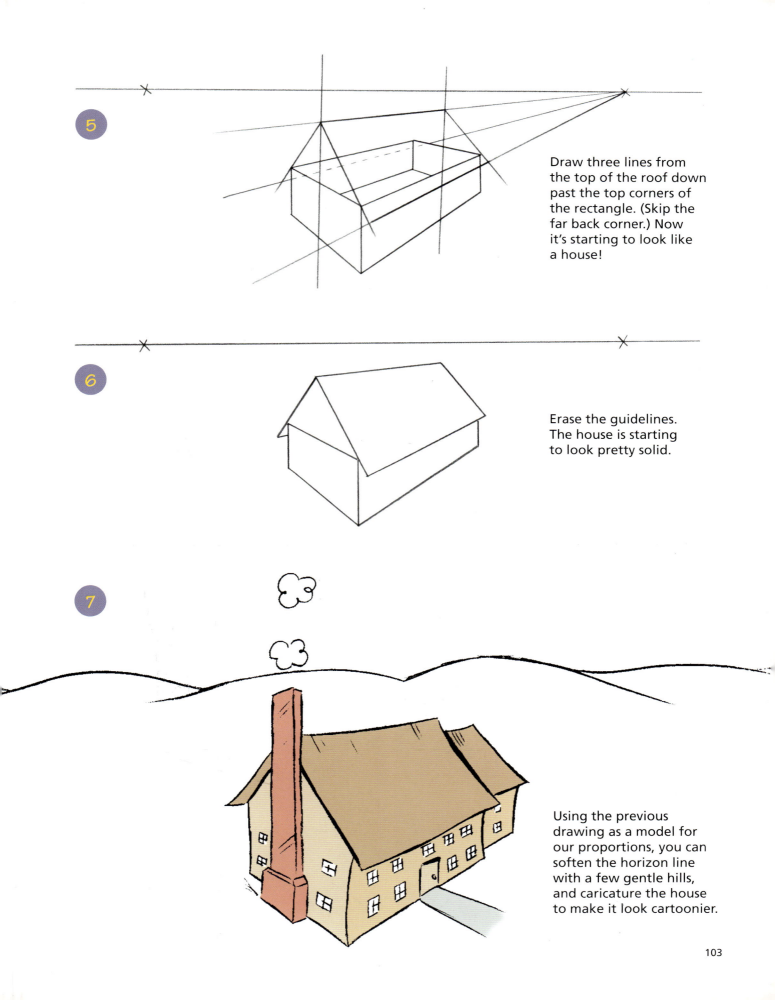

VANISHING POINTS THAT APPEAR OFF THE PAGE

Quite often, an object in two-point perspective has vanishing points spaced too far apart to appear within the borders of the page. If we kept this house as large as it appears here, and moved the vanishing points closer together, the house would look severely distorted. Instead, we have placed the vanishing points further apart, off the page. The same rules apply as for visible vanishing points, though, and if you were to draw lines extending from the corners of the house (as indicated by the arrows), they would still converge at the horizon line.

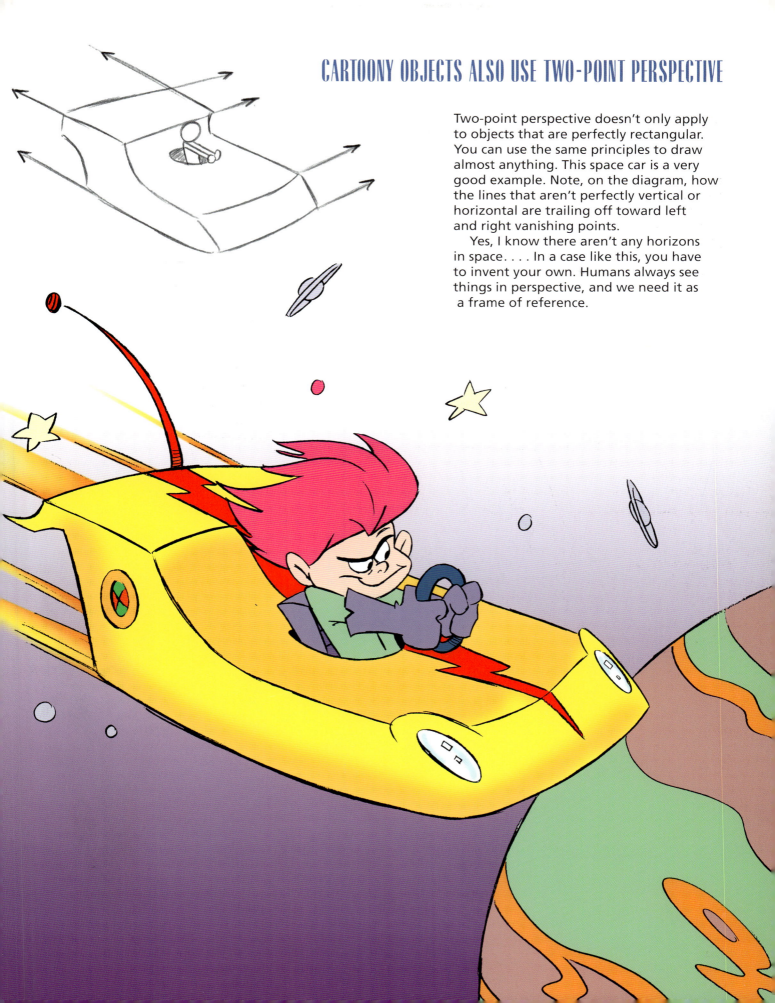

CARTOONY OBJECTS ALSO USE TWO-POINT PERSPECTIVE

Two-point perspective doesn't only apply to objects that are perfectly rectangular. You can use the same principles to draw almost anything. This space car is a very good example. Note, on the diagram, how the lines that aren't perfectly vertical or horizontal are trailing off toward left and right vanishing points.

Yes, I know there aren't any horizons in space. . . . In a case like this, you have to invent your own. Humans always see things in perspective, and we need it as a frame of reference.

DRAWING THE CORRECT HEIGHT OF A CHARACTER IN PERSPECTIVE

Have you ever drawn a person against a background, only to have it appear as if the person were floating? That is a common perspective problem that is easily remedied. Here is a simplified method I've devised that can quickly give you the correct proportions.

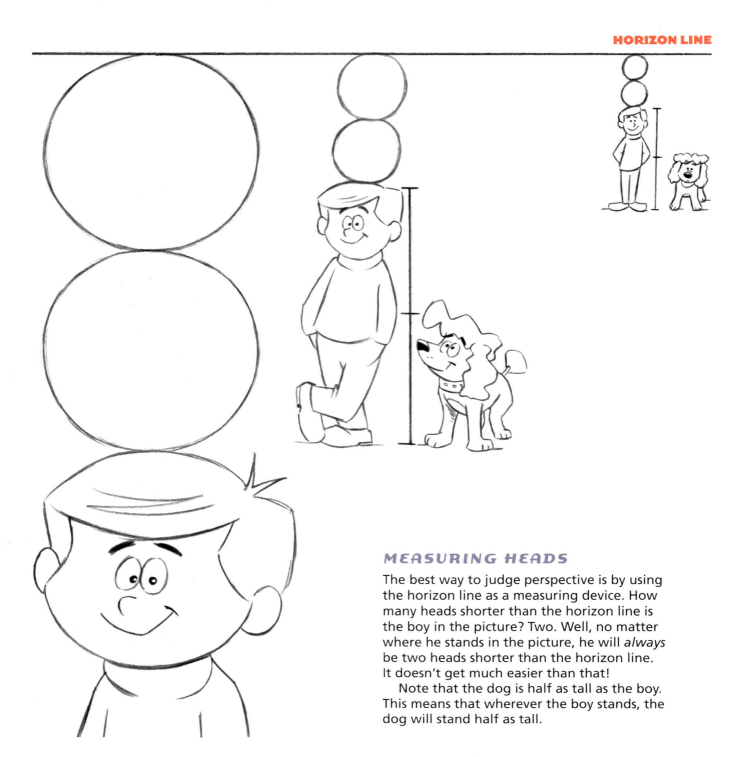

MEASURING HEADS

The best way to judge perspective is by using the horizon line as a measuring device. How many heads shorter than the horizon line is the boy in the picture? Two. Well, no matter where he stands in the picture, he will *always* be two heads shorter than the horizon line. It doesn't get much easier than that!

Note that the dog is half as tall as the boy. This means that wherever the boy stands, the dog will stand half as tall.

DRAWING THE CORRECT HEIGHT FOR CHARACTERS WHO STAND ABOVE THE HORIZON LINE

When a character's head is *above* the horizon line, we can't measure him the way we just learned. But we *can* still use the horizon line to keep him in proportion. Just look for the point on the character's body where the line hits him, and make sure it hits him at that point no matter what size you draw him. In this case, the horizon line touches the man just below the knee. Therefore, wherever he stands in the picture, the horizon line will always cross him just below the knee.

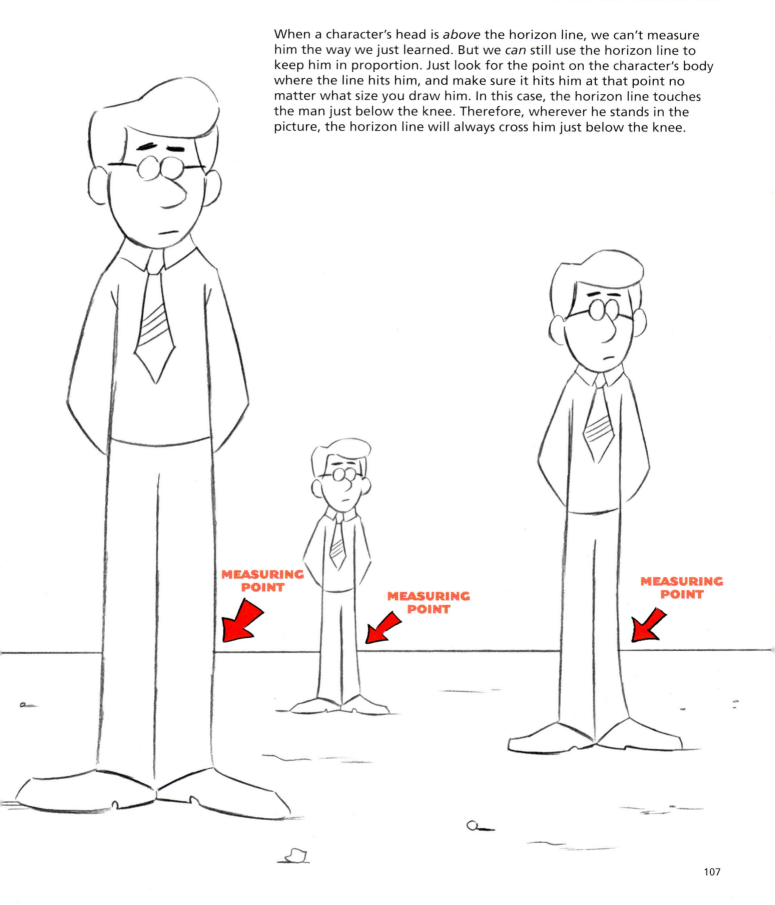

MEASURING POINT

MEASURING POINT

MEASURING POINT

DRAWING CHARACTERS OF DIFFERENT HEIGHTS IN PERSPECTIVE

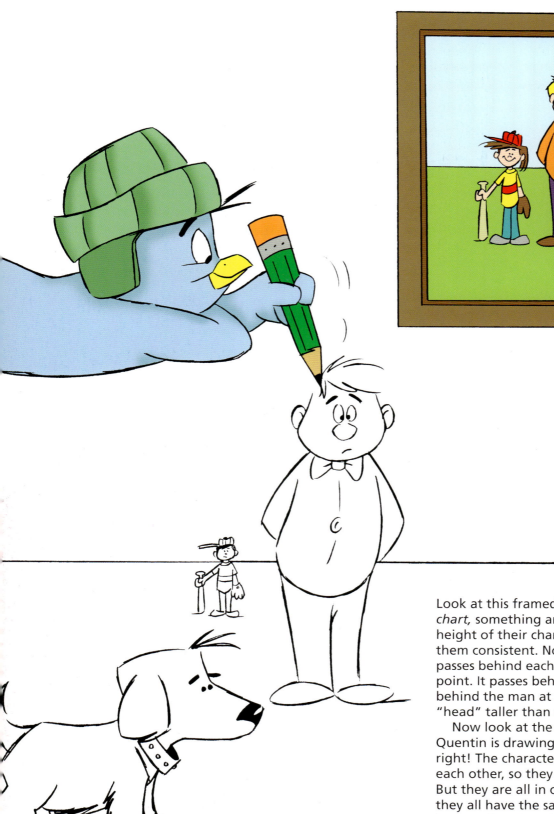

Look at this framed picture. It's really a *height chart,* something animators use to judge the height of their characters in order to keep them consistent. Notice how the horizon line passes behind each character at a different point. It passes behind the boy at his neck and behind the man at his belly, and it is one doggy "head" taller than the dog.

Now look at the scene that our little friend Quentin is drawing for us. Yep, he's got it right! The characters aren't standing next to each other, so they are vastly different sizes. But they are all in correct perspective because they all have the same relationship to the horizon line that they did in the chart.

ARE THESE TWO DOGS THE SAME HEIGHT?

I have chosen the line where the tiled floor meets the bottom of the front door as the horizon line. That being the case, can you deduce whether these two dogs are the same height?

Each dog is about one of its own heads shorter than the horizon line, so yes, they are about the same height. If you moved the poodle a few inches toward the bottom of the page, she would suddenly appear to be much smaller than the pup in the foreground.

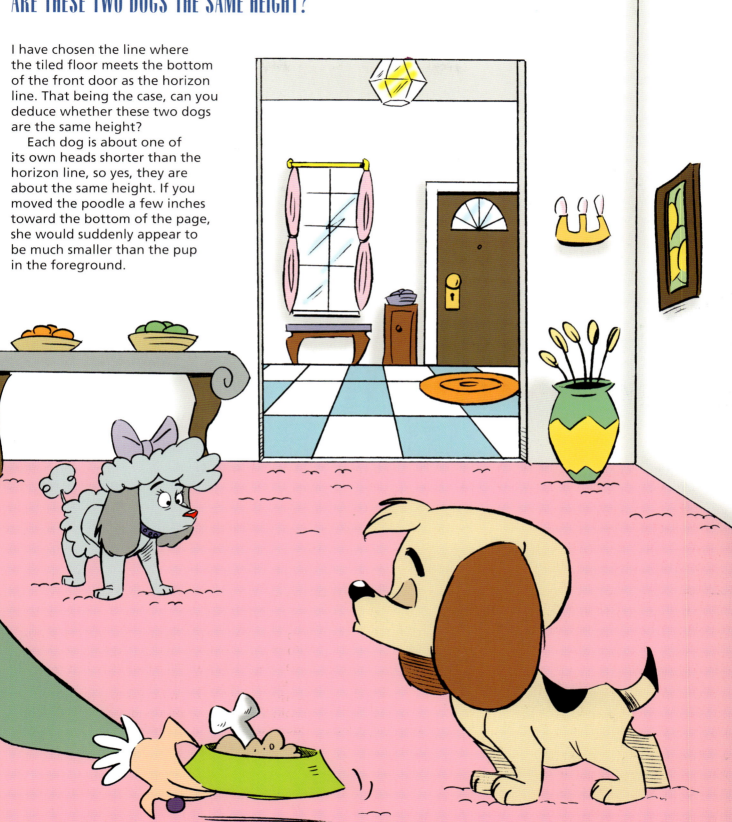

HOW CURVED LINES CHANGE IN PERSPECTIVE

When you are looking *down* at a curved line that is basically horizontal, it tends to curve *upward.* When you look *up* at a curved line that is basically horizontal, it tends to bend *downward.* When placed at the horizon line, a curved line will flatten, becoming *straight.*

You may not have noticed this subtle effect, but when incorporated throughout a drawing, it can be quite powerful. Getting it right shows that you know what you're doing as an artist.

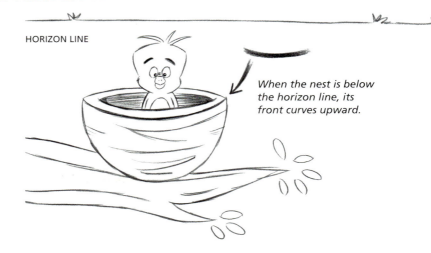

HORIZON LINE

When the nest is below the horizon line, its front curves upward.

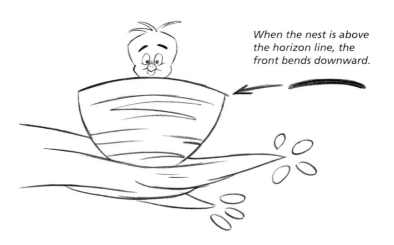

When the nest is above the horizon line, the front bends downward.

HORIZON LINE

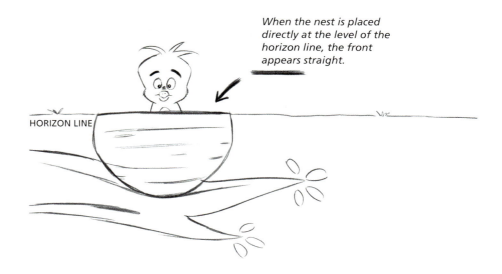

When the nest is placed directly at the level of the horizon line, the front appears straight.

HORIZON LINE

CURVED LINES ON THE HUMAN FIGURE IN PERSPECTIVE

This man's body is both above *and* below the horizon line. Look at the effect that has on how we draw him. The curves above the horizon line bend down. The curves below the horizon line curve up.

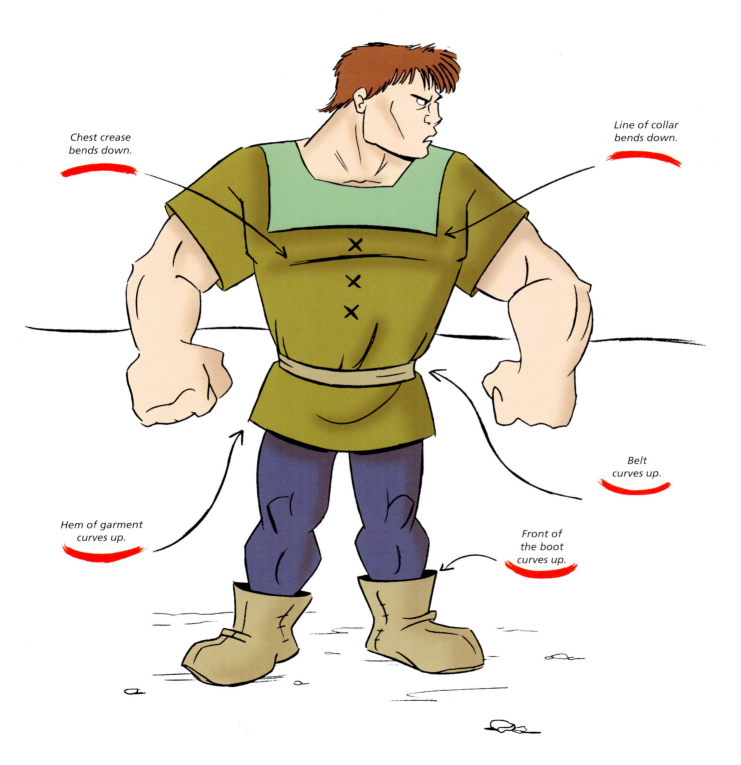

Chest crease bends down.

Line of collar bends down.

Belt curves up.

Hem of garment curves up.

Front of the boot curves up.

INANIMATE OBJECTS' CURVES IN PERSPECTIVE

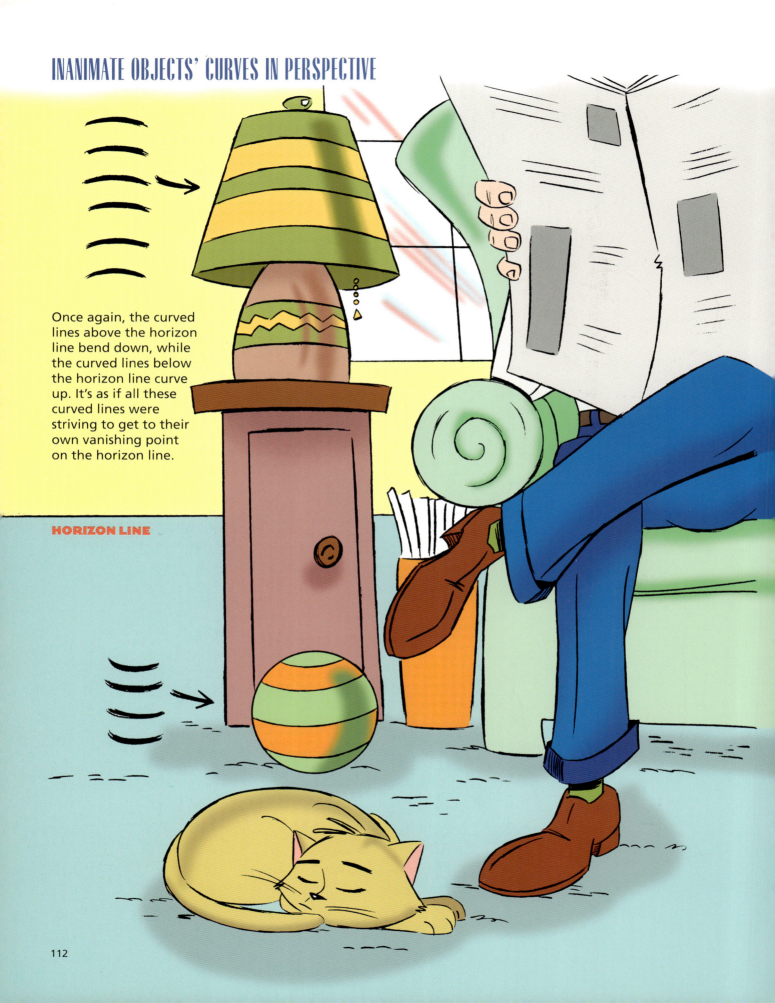

Once again, the curved lines above the horizon line bend down, while the curved lines below the horizon line curve up. It's as if all these curved lines were striving to get to their own vanishing point on the horizon line.

HORIZON LINE

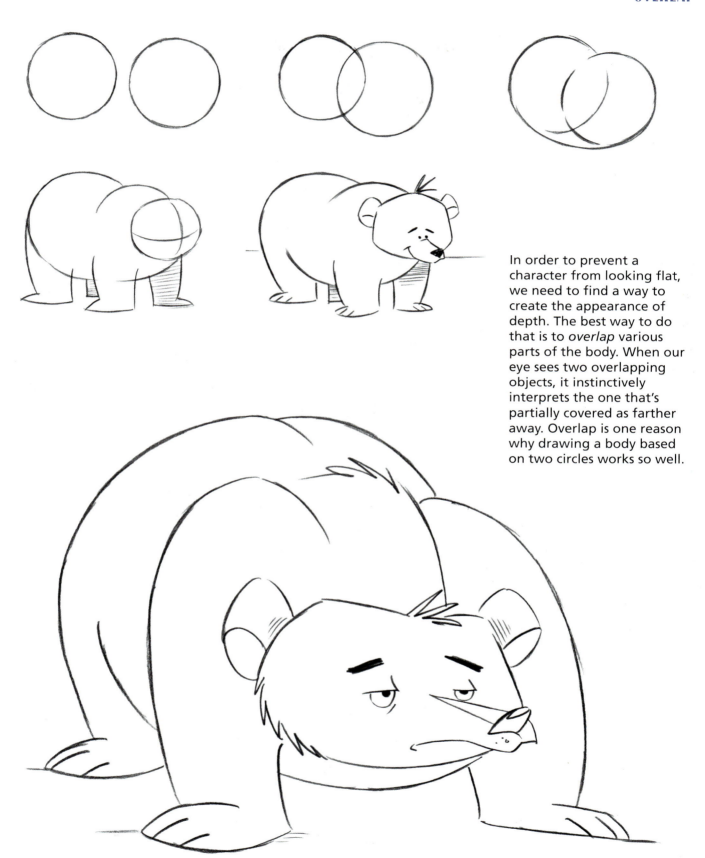

In order to prevent a character from looking flat, we need to find a way to create the appearance of depth. The best way to do that is to *overlap* various parts of the body. When our eye sees two overlapping objects, it instinctively interprets the one that's partially covered as farther away. Overlap is one reason why drawing a body based on two circles works so well.

DRAWING "Realistic" Cartoons

Not every cartoon character has a big nose and three-fingered hands. In this section, we'll explore how to draw cartoons that borrow more closely from real life. This does not mean that the cartoony feeling will be gone; far from it!

Classic feature animation is famous for using more naturalistic characters as the stars. For example, Tramp, that lovable rascal from the Disney film *Lady and the Tramp,* was a more realistic cartoon character than Charles Schulz's Snoopy. Moses, in the animated feature *The Prince of Egypt,* is a much more realistic cartoon character than Tommy of *Rugrats* fame. They are all still cartoons, but while the simpler ones are wacky, the more realistic ones are capable of conveying more complex emotions and carrying the weight of a feature film story.

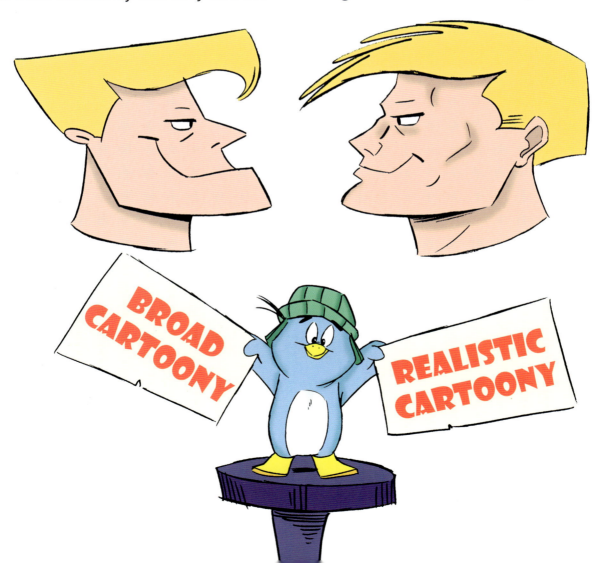

BROAD CARTOONY

REALISTIC CARTOONY

THE NORMAL CARTOON HEAD VS. THE "REALISTIC" CARTOON HEAD

As you can see, the realistic head has more angles and planes than the classic cartoon head; it bears a much closer resemblance to real human anatomy. Heroes and leading men are almost always drawn with realistic heads.

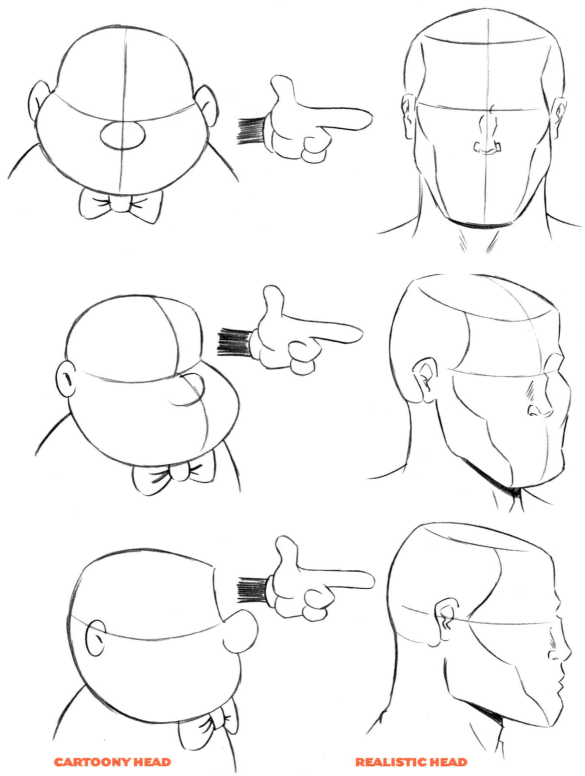

CARTOONY HEAD

REALISTIC HEAD

ONE CHARACTER, TWO STYLES

JUNGLE MAN

The cartooning style you choose will affect the image your character projects and therefore how he or she functions within the cartoon universe. Look at the difference between these two versions of the jungle man. While both display the same basic characteristics, they are obviously cut out for different roles. The one on top, drawn in a broad, cartoony style, would be great for physical comedy. The more realistic jungle man would be better suited to handling a reasonably developed story line.

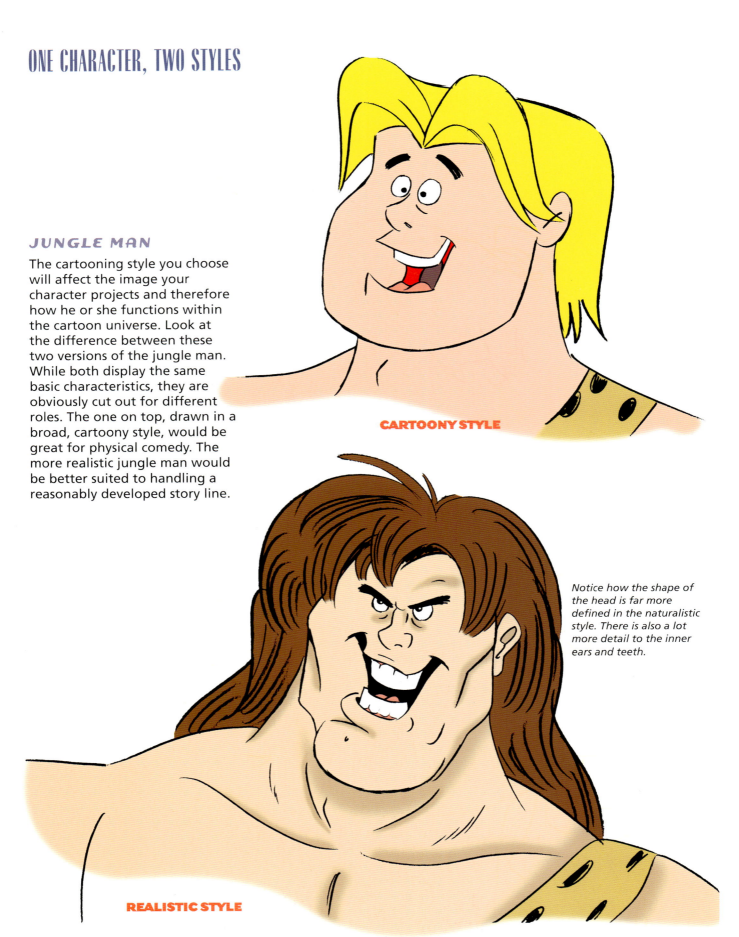

CARTOONY STYLE

Notice how the shape of the head is far more defined in the naturalistic style. There is also a lot more detail to the inner ears and teeth.

REALISTIC STYLE

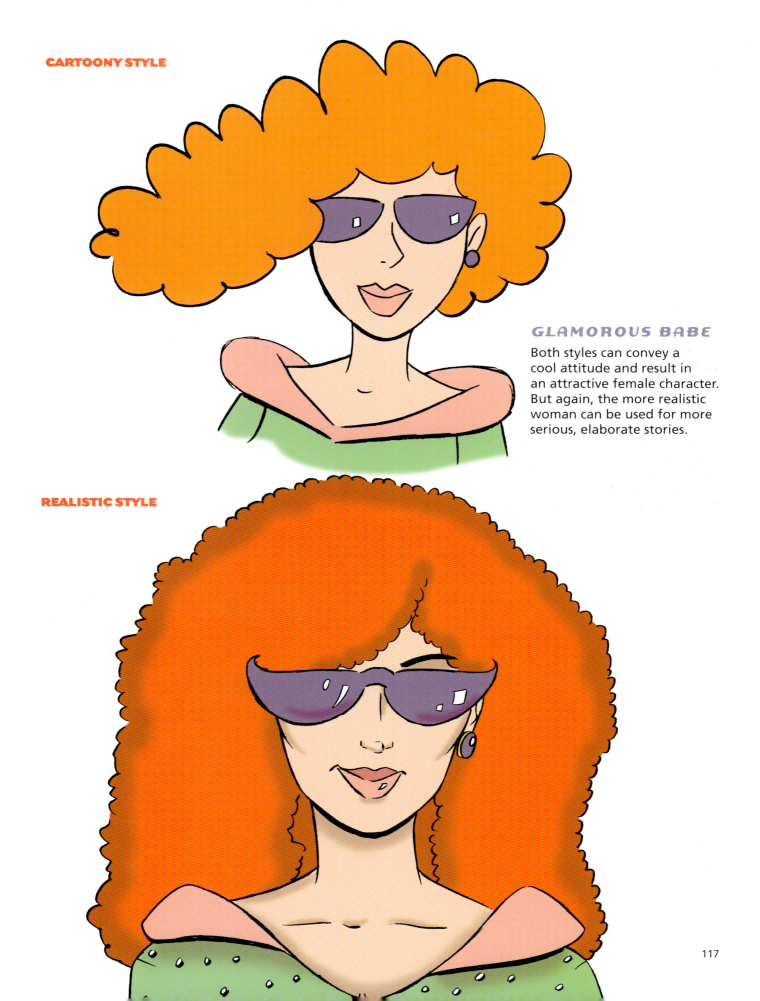

CARTOONY STYLE

REALISTIC STYLE

GLAMOROUS BABE

Both styles can convey a cool attitude and result in an attractive female character. But again, the more realistic woman can be used for more serious, elaborate stories.

117

DRAWING REALISTIC CARTOON WOMEN

By examining the construction stages of these realistically drawn women, you can see how much they differ from broadly drawn female characters.

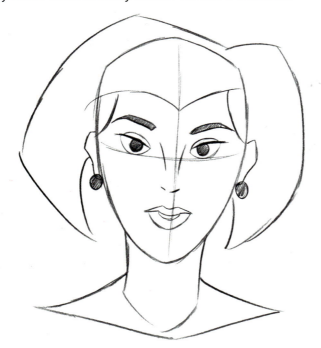

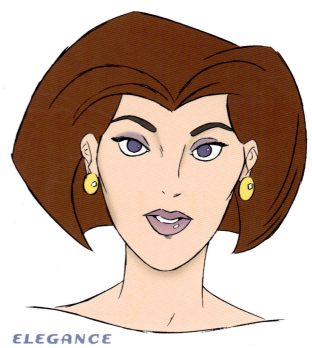

ELEGANCE

Notice the very limited angles of the face—only the cheekbones protrude, and only slightly. The eyes are by far the most important facial feature here. They are subtle and refined.

CARELESS GOOD LOOKS

The wind-blown, ruffled hair gives this attractive character a racy feeling, as do those heavy eyelids and full lips. Notice that using heavy eyebrows can actually make pretty cartoon women prettier! Very thin eyebrows have the opposite effect: they decrease the emphasis on the eyes, and are used mainly for severe, evil characters. Note, too, that this woman's facial structure is different from the elegant character's, and yet, as in the elegant character's face, the cheekbones are the only area that protrudes.

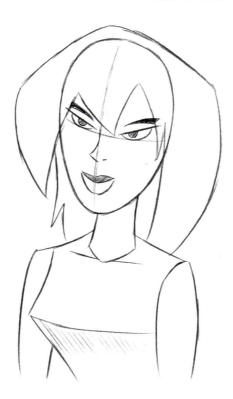

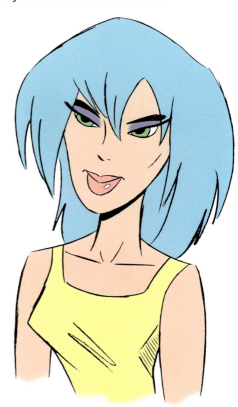

PRETTY AND EARNEST

The large forehead reminds us, subconsciously, of a baby's forehead, leading us to link this woman with the qualities associated with an infant: sweetness, goodness, and innocence. The eyes are big, and so are the pupils —which translates into a feeling of honesty and purity. Slightly rounded cheeks soften her further.

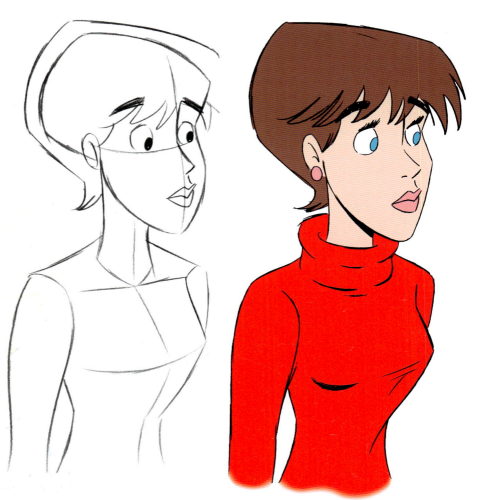

- ◆ HAIR: more elaborately styled
- ◆ FACE: thinner, revealing more bone structure
- ◆ EYES: smaller, with heavier eyelids
- ◆ EYEBROWS: heavier
- ◆ NOSE: more delicate; lightly drawn
- ◆ LIPS: fuller and shapelier
- ◆ CHIN: longer (made possible by thinner face)

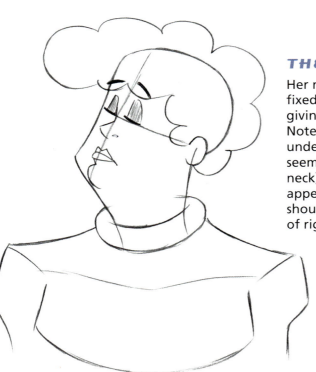

THE SNOB

Her nose is permanently fixed in an upturned position, giving her a haughty look. Note the flared nostril. Her undefined jawline (her chin seems to disappear into her neck) gives her a well-fed appearance, and the square shoulders add a sense of rigidity.

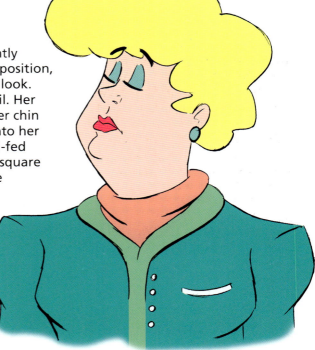

DRAWING REALISTIC CARTOON MEN

While a realistic-style cartoon woman's features can be drawn lightly, with little detail, men's features are bolder, and therefore are drawn in greater detail. You can clearly see the main differences between realistically and broadly drawn cartoon men.

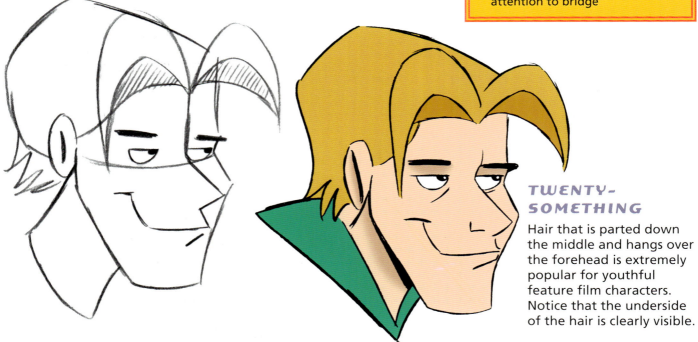

TWENTY-SOMETHING

Hair that is parted down the middle and hangs over the forehead is extremely popular for youthful feature film characters. Notice that the underside of the hair is clearly visible.

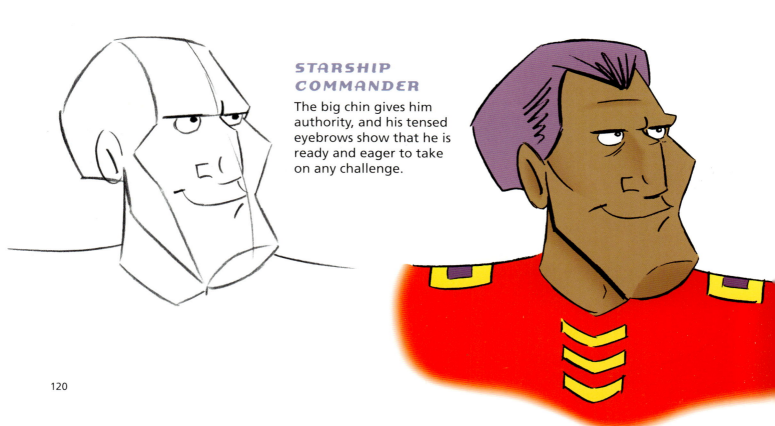

STARSHIP COMMANDER

The big chin gives him authority, and his tensed eyebrows show that he is ready and eager to take on any challenge.

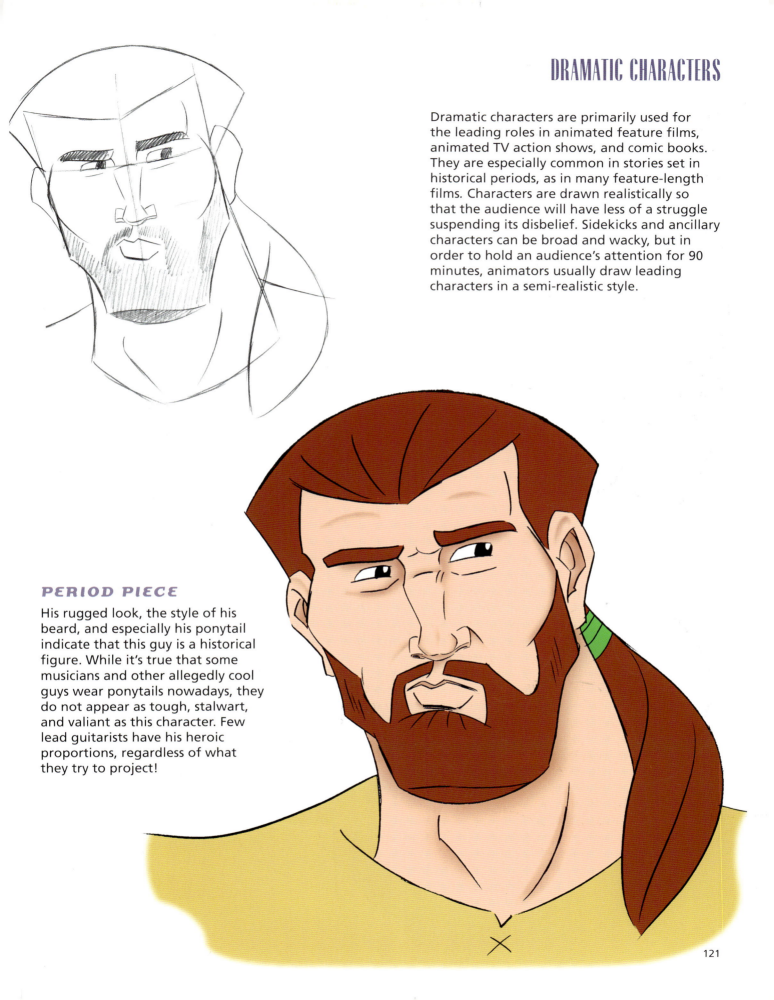

Dramatic characters are primarily used for the leading roles in animated feature films, animated TV action shows, and comic books. They are especially common in stories set in historical periods, as in many feature-length films. Characters are drawn realistically so that the audience will have less of a struggle suspending its disbelief. Sidekicks and ancillary characters can be broad and wacky, but in order to hold an audience's attention for 90 minutes, animators usually draw leading characters in a semi-realistic style.

PERIOD PIECE

His rugged look, the style of his beard, and especially his ponytail indicate that this guy is a historical figure. While it's true that some musicians and other allegedly cool guys wear ponytails nowadays, they do not appear as tough, stalwart, and valiant as this character. Few lead guitarists have his heroic proportions, regardless of what they try to project!

DRAMATIC CARTOON WOMAN

Dramatic cartoon women are used primarily as attractive lead characters, evil witch-types, and mothers. When drawing a leading lady, remember that while the realistic-style man's face has lots of angles and facial details, her face should be simple, with a softly curving outline and slightly protruding cheekbones. However, don't confuse *simple-looking* with *easy to draw.* Knowing what to leave out is as much of an art as knowing what to add.

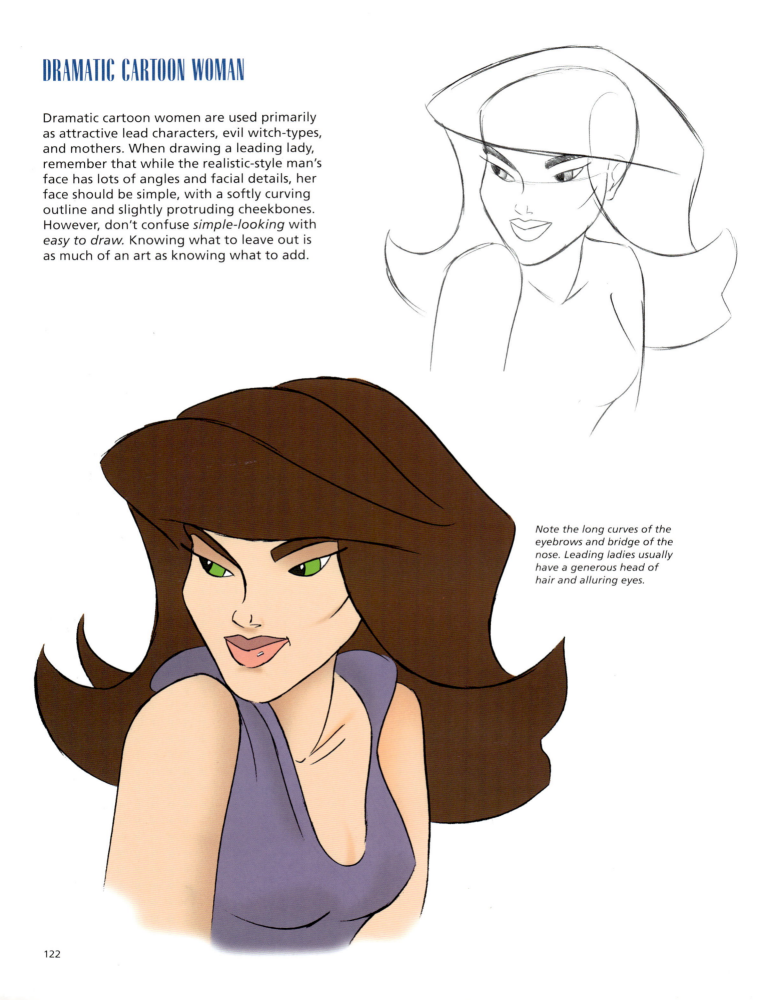

Note the long curves of the eyebrows and bridge of the nose. Leading ladies usually have a generous head of hair and alluring eyes.

These drawings show the basic building blocks of realistic male and female cartoon characters. You don't have to rigidly adhere to these guidelines; you can simplify the forms further, or create your own template if you feel particularly confident. However, it's important to pay attention to the three main areas in the body's design, to which everything else is attached.

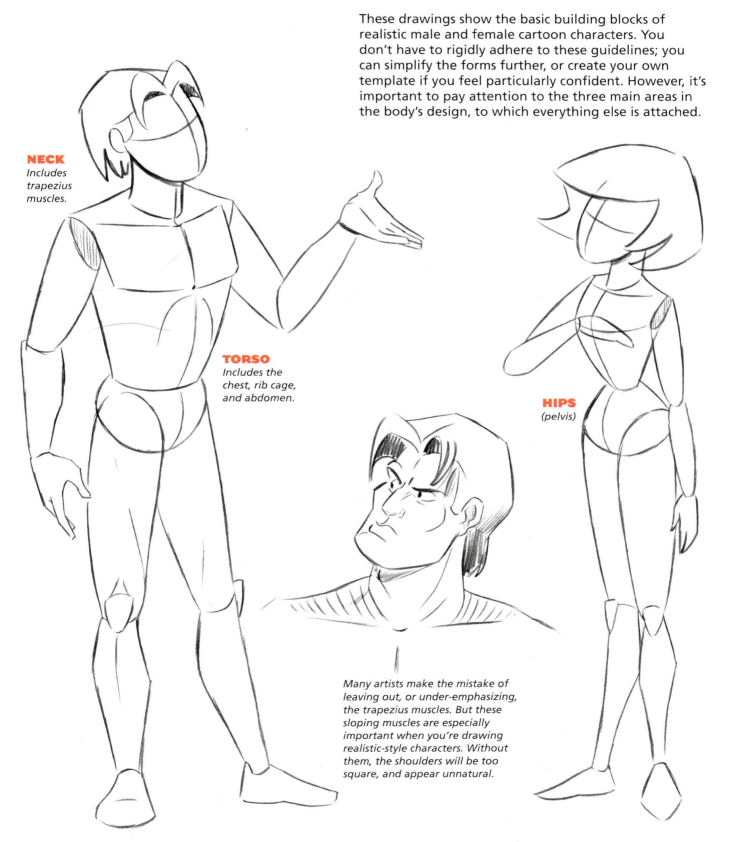

NECK
Includes trapezius muscles.

TORSO
Includes the chest, rib cage, and abdomen.

HIPS
(pelvis)

Many artists make the mistake of leaving out, or under-emphasizing, the trapezius muscles. But these sloping muscles are especially important when you're drawing realistic-style characters. Without them, the shoulders will be too square, and appear unnatural.

MORE ON REALISTIC CARTOON BODIES

Sure, drawings like these are challenging for a beginning cartoonist. But they are by no means impossible. You may not feel at ease with this section yet, but give it a try. It will make the cartoonier characters seem that much easier to draw in comparison. In addition, you'll notice that although the finished drawings may appear somewhat complicated, their initial construction steps are relatively simple. Everything is based on that first construction step, so if you can get through that—and I believe that with a little practice you can—you'll find that the final step is only 10% of the work!

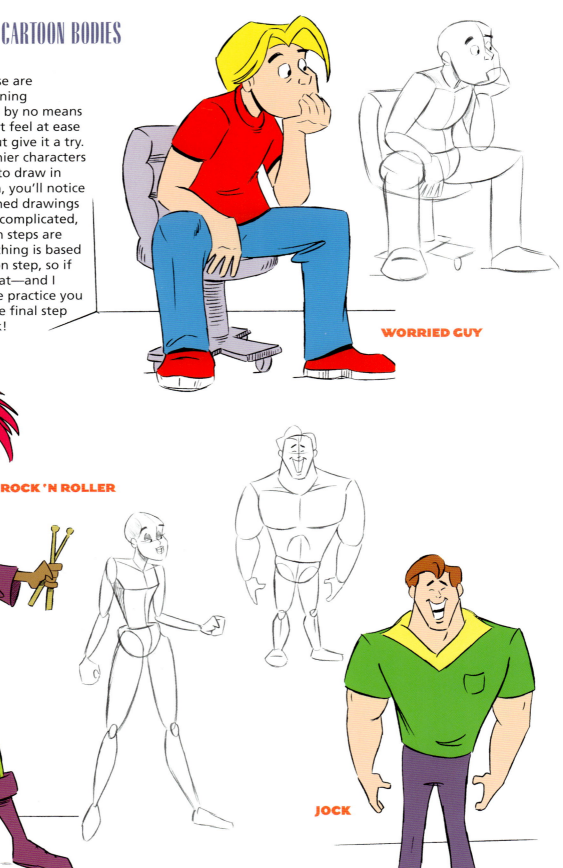

WORRIED GUY

ROCK 'N ROLLER

JOCK

124

FATTER = CARTOONIER

Adding a lot of weight to a character will stretch and fill out the body to the point where you'll have to go back to a more cartoony construction. The fat body is best drawn as one large, malleable form. Note the difference in the construction steps for these two equestriennes.

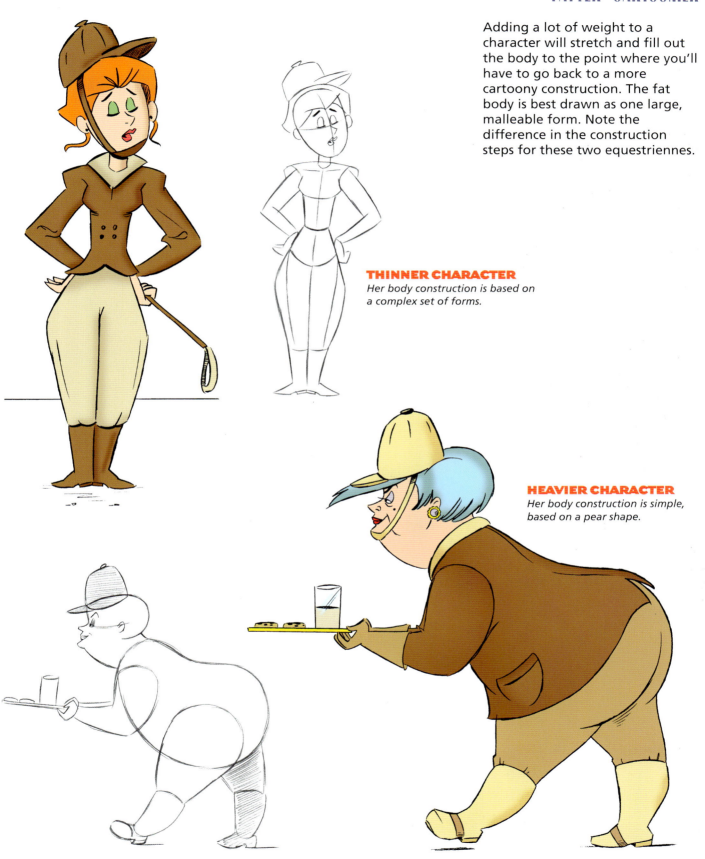

THINNER CHARACTER
Her body construction is based on a complex set of forms.

HEAVIER CHARACTER
Her body construction is simple, based on a pear shape.

DRAWING REALISTIC KIDS

Children are the easiest subjects to draw as realistic cartoon characters. Because their faces and bodies are naturally rounder than those of adults, their constructions are more similar to ones used for broader cartoons. Use a soft, subtle touch when drawing the outline of the face. Give your kid a small, but not pointy, chin; wide cheeks; and a large forehead. A small, rounded nose is a reliable option.

For the body, keep things simple. The separation between the torso and the hip area should not be significant. Little girls don't really have waists, and little boys shouldn't be drawn with developed chests and rib cages on top of narrow hips. They're still built like string beans! Give your kid rounded shoulders and a small but definite tummy, which reads as youthful.

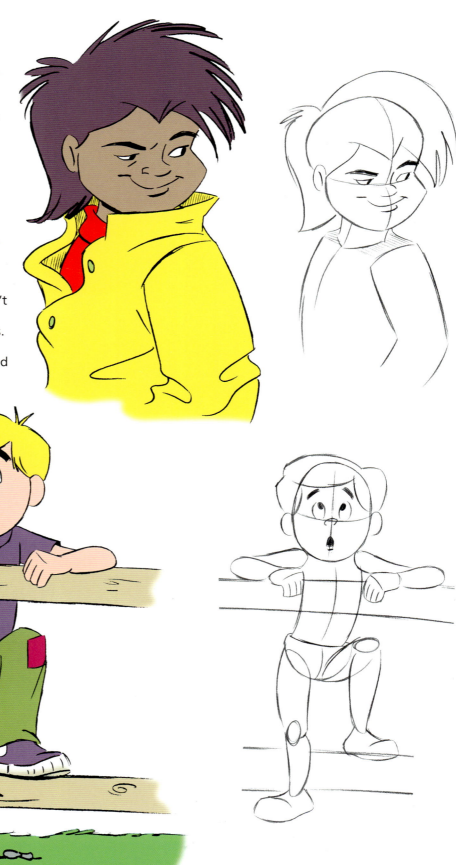

This subject has never been covered in a book on cartooning before, at least to my knowledge. And that's a shame, because it's so crucial. With the benefit of just a few pointers on drawing realistic creases, folds, and wrinkles, you will be able to create terrific-looking characters. The difficulty is not in the design of the clothing itself, but in the looping folds and creases are caused by a person *moving* in the clothing. If you don't know how to draw these creases, you'll end up scratching meaningless, unconvincing lines on pants and shirts. Come on, let's solve this problem!

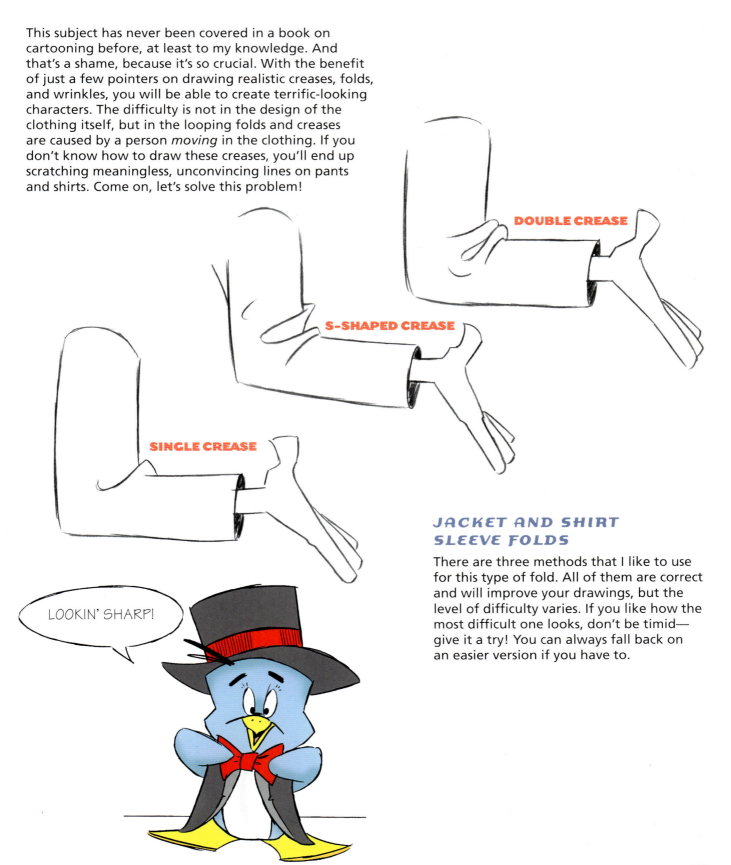

DOUBLE CREASE

S-SHAPED CREASE

SINGLE CREASE

LOOKIN' SHARP!

JACKET AND SHIRT SLEEVE FOLDS

There are three methods that I like to use for this type of fold. All of them are correct and will improve your drawings, but the level of difficulty varies. If you like how the most difficult one looks, don't be timid—give it a try! You can always fall back on an easier version if you have to.

PANT CREASES

Pants have long creases and short creases. The long creases tend to be vertical while the short creases tend to be horizontal. At the places where the clothes are compressed into a bunch of wrinkles—the *compression points*—the creases radiate outward.

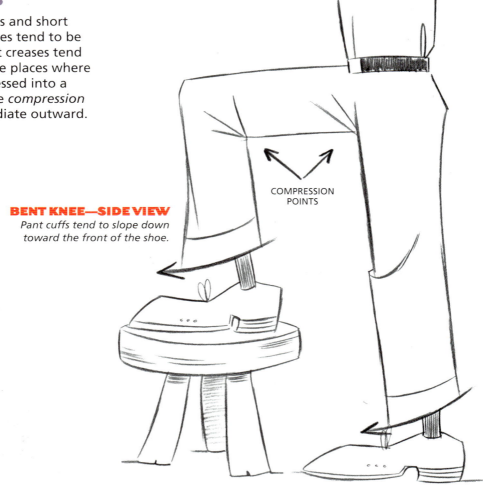

COMPRESSION POINTS

BENT KNEE—SIDE VIEW

Pant cuffs tend to slope down toward the front of the shoe.

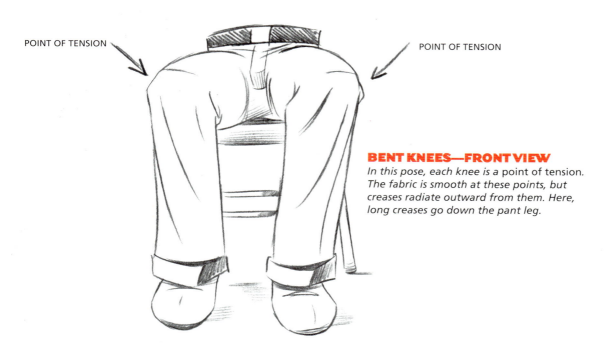

POINT OF TENSION

POINT OF TENSION

BENT KNEES—FRONT VIEW

In this pose, each knee is a point of tension. The fabric is smooth at these points, but creases radiate outward from them. Here, long creases go down the pant leg.

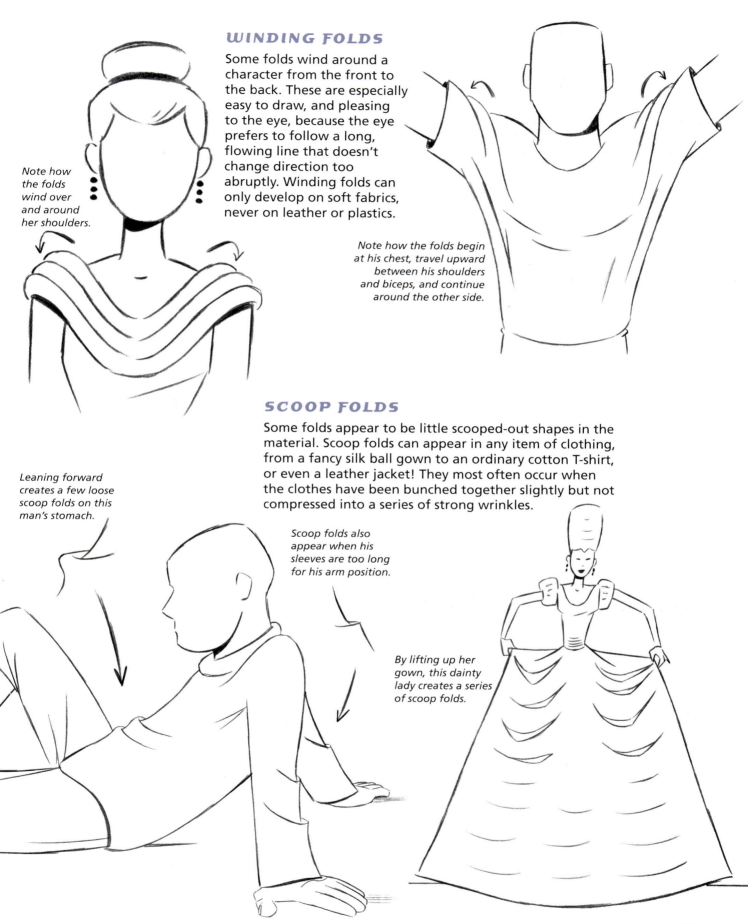

WINDING FOLDS

Some folds wind around a character from the front to the back. These are especially easy to draw, and pleasing to the eye, because the eye prefers to follow a long, flowing line that doesn't change direction too abruptly. Winding folds can only develop on soft fabrics, never on leather or plastics.

Note how the folds wind over and around her shoulders.

Note how the folds begin at his chest, travel upward between his shoulders and biceps, and continue around the other side.

SCOOP FOLDS

Some folds appear to be little scooped-out shapes in the material. Scoop folds can appear in any item of clothing, from a fancy silk ball gown to an ordinary cotton T-shirt, or even a leather jacket! They most often occur when the clothes have been bunched together slightly but not compressed into a series of strong wrinkles.

Leaning forward creates a few loose scoop folds on this man's stomach.

Scoop folds also appear when his sleeves are too long for his arm position.

By lifting up her gown, this dainty lady creates a series of scoop folds.

SKIRTS AND BLOUSES

A rudimentary understanding of folds is helpful, even necessary, in order to draw skirts and blouses accurately. Without correctly-drawn folds, skirts look stiff, and blouses may look too suggestive.

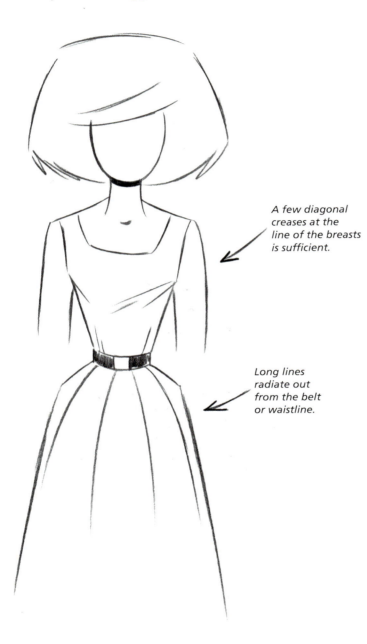

A few diagonal creases at the line of the breasts is sufficient.

Long lines radiate out from the belt or waistline.

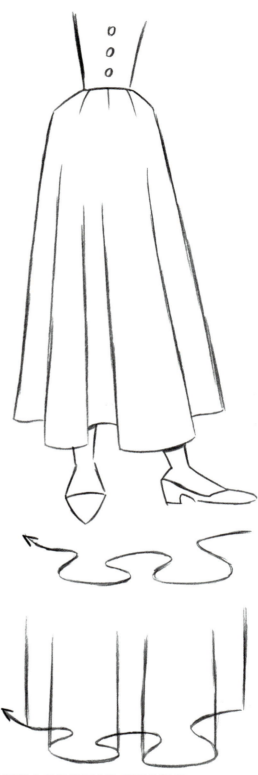

OVERLAPPING FOLDS

Long dresses, curtains, gowns, and Victorian sleeves have overlapping folds. To create these folds, first draw a squiggly line to represent the bottom of the material. Next, draw vertical lines attached to the *outside* of the curves, as shown here. Finally, erase the interior folds which are not visible to the reader, and you'll have it!

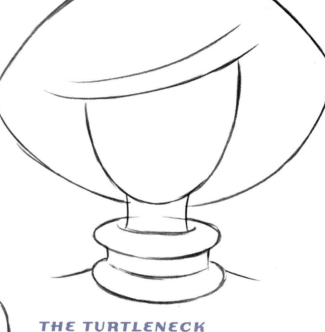

THE COLLAR

The collar is based on an oval shape that surrounds the neck—*not* a perfect circle. Note the **M** shape in the middle of the shirt, where the collar meets the shirt.

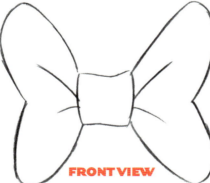

FRONT VIEW

BOW TIES

Although they have fallen out of favor with the general population, bow ties continue to be popular accessories for cartoon characters. Cartoonists like them because they are silly looking! They are also useful for making cartoon animals appear more human.

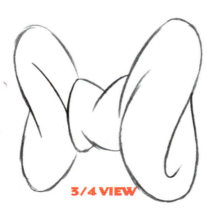

3/4 VIEW

THE TURTLENECK

The turtleneck shirt is not normally this highly defined. I've exaggerated the form somewhat in order to highlight the fact that turtleneck collars have not one, but *two* rings around the neck. When you draw your own turtleneck, you should soften the collar's appearance.

131

DRAWING
Edgy 'Toons

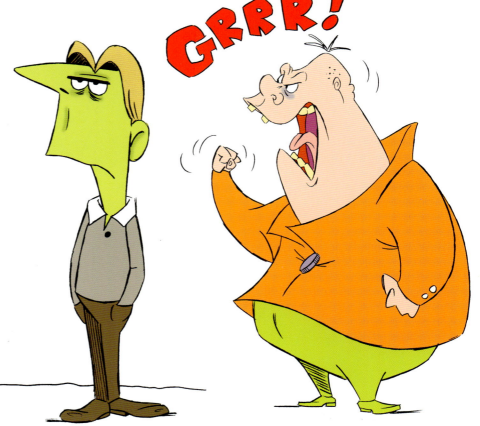

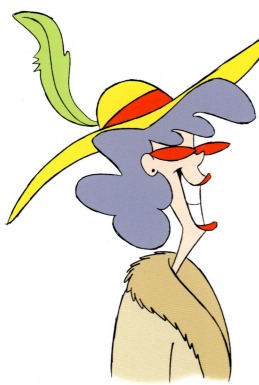

If you watch the cable TV station The Cartoon Network, particularly shows like *Cow and Chicken* and *Ed, Edd 'n Eddy,* you'll notice that the way the characters are drawn is different from traditional cartoon drawing styles. The same is true for some newer comic strips. They're uglier, but in a *funny* way. It's almost as if their cartoons have a special *edge* to them. No book on modern cartooning would be complete without a section devoted to this exciting new style of cartooning.

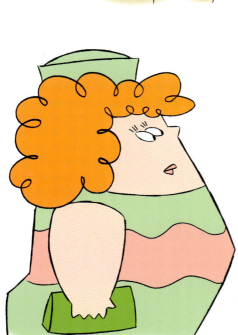

GRRR!

BE EXTREME

Subtleties have no place in "edgy" cartoons. It's all about going beyond the normal comfort zone. That's why so many misshapen characters appear in edgy animated TV shows. And because edgy cartoons have become popular, cartoon-watching audiences have gotten used to them, which means that cartoonists have had to push the boundaries *even more* in order to get that edgy look.

A word of caution: Edgy cartoons are visually demanding of an audience. They can become tiresome because they constantly push the creative envelope. They are more cutting edge, but they do not attract as wide an audience as classical cartooning. Nonetheless, some hugely popular cartoons have been completely edgy, like MTV's *Beavis and Butthead.*

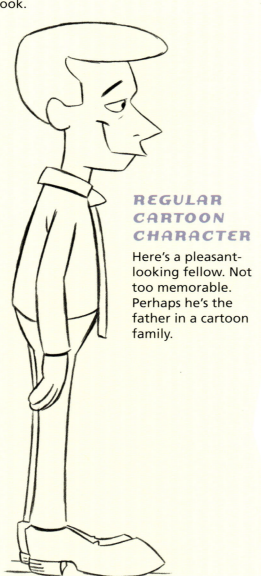

REGULAR CARTOON CHARACTER

Here's a pleasant-looking fellow. Not too memorable. Perhaps he's the father in a cartoon family.

EDGY CARTOON CHARACTER

This man looks slightly deranged. That's typical of edgy cartoons; demented and quirky are the key words. In addition, notice how the graphic boundaries have been stretched. He has sinister eyes and a unibrow. His ear sticks out oddly and he has a weird point of hair sticking up in the back. And check out his extra-long arms and strange, floating tie.

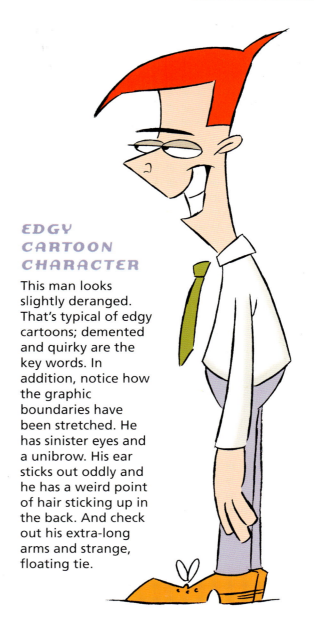

REGULAR ANIMALS VS. EDGY ANIMALS

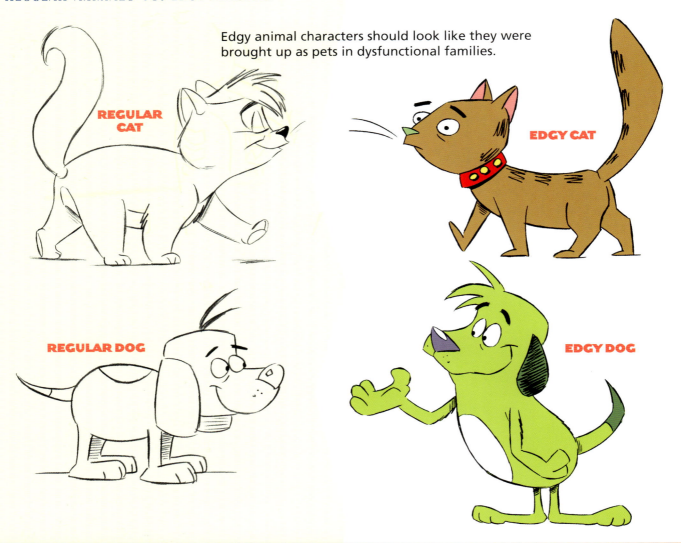

Edgy animal characters should look like they were brought up as pets in dysfunctional families.

REGULAR CAT

EDGY CAT

REGULAR DOG

EDGY DOG

EDGY 'TOONS BASED ON IRREGULAR HEAD SHAPES

You can give your cartoon creations an edgy look by using extreme and oversized head shapes. Wide-set eyes with slightly wandering pupils were first popularized by the TV show *The Simpsons*. Since its debut, the look's popularity in both animation and print has grown by leaps and bounds.

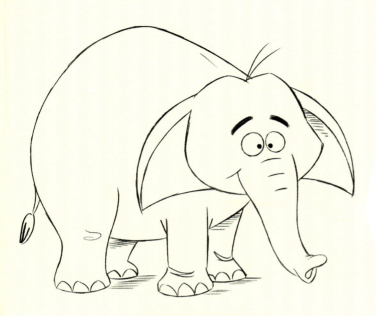

REGULAR ELEPHANT

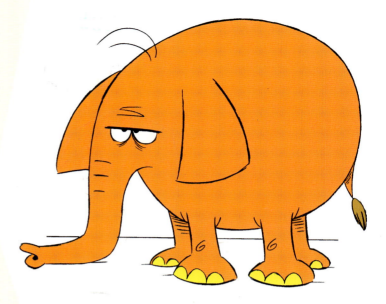

EDGY ELEPHANT

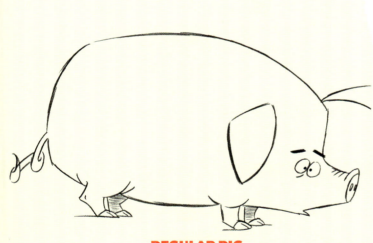

REGULAR PIG

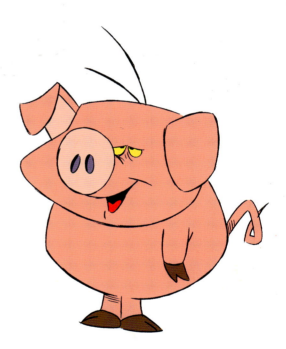

EDGY PIG

Don't worry about getting the anatomy and proportions right on an edgy cartoon character. In fact, if you've got all the proportions right, you've got the cartoon wrong—wrong for an edgy style, that is!

MORE EDGY CHARACTERS

EDGY CHARACTERS ON EDGE!

It's fun to take a character who is extreme to begin with, and then push that character a few more yards over the top. The stereotypical military man is a good example of an extreme type. I don't mean to say anything untoward about our brave fighting men, but they do live by a very tough, rigid code; they are trained to be aggressive fighting machines, in attitude and appearance. Add a bit of demented edginess to your military man, and you can make him seem downright diabolical.

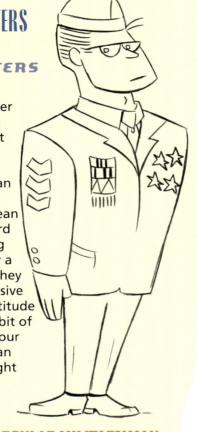

REGULAR MILITARY MAN

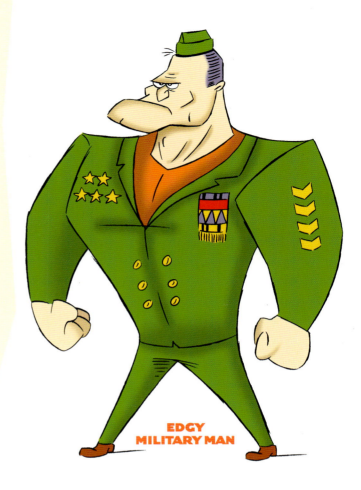

EDGY MILITARY MAN

EDGY SUBURBANITES

We all suspect that behind the white picket fences and lush, manicured lawns of suburbia lies many a family with at least one ax murderer in it. Suburban families are great subject matter for edgy cartoons.

EDGY HOUSEWIFE

Scary, huh? Notice how low on her face the eye is placed. It actually appears below her nose, which is physically impossible. Also notice how long her mouth is. Any longer than that, and it would cut her neck in half. Her gravity-defying bottom is huge, and her hair has been nourished on nothing more than peroxide for the last twenty years.

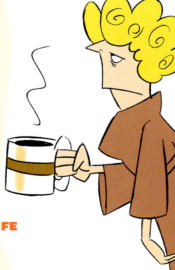

REGULAR HOUSEWIFE

Don't ever draw a picture of your mom dressed like this. She'll make you burn it. Trust me. I know.

EDGY TEENS

Teenagers already look a little edgy, with their long hair, lanky limbs, and odd dress. So it's up to you as a cartoonist to ratchet it up a few more notches in each category.

Teenagers like to make a statement with their hair. As a cartoonist trying to create an edgy character, go for the obvious. Let the statement be, "My hair is ridiculous, and I'm proud of it!"

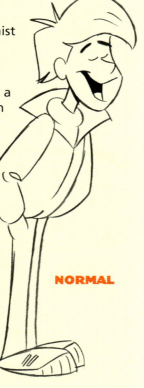

NORMAL

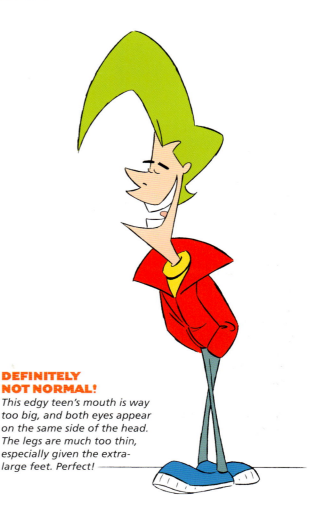

DEFINITELY NOT NORMAL!

This edgy teen's mouth is way too big, and both eyes appear on the same side of the head. The legs are much too thin, especially given the extra-large feet. Perfect!

EDGINESS TURNS ONE CHARACTER INTO ANOTHER

By merely adding an edge to a character, you can turn it into something completely different.

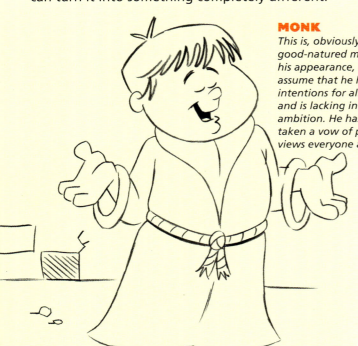

MONK

This is, obviously, a genteel and good-natured monk. Based on his appearance, one would assume that he has good intentions for all of mankind and is lacking in personal ambition. He has no doubt taken a vow of poverty and views everyone as his brother.

EVIL CULT LEADER

By adding an edgy quality, we have transformed our kindly monk into someone who's dripping with insincere sincerity. Bent on world domination, no doubt he's building an underground bunker for his faithful while plotting the destruction of the rest of the world.

RUDE 'TOONS

In the world of animated kids' TV shows, "cutting edge" used to mean "violent." Today, it means "rude." Bad taste is definitely in; gross-out humor is now considered acceptable, even for very young kids. But there is much more to rude 'toons than crude pictures and bathroom humor. The ruder the cartoon, the more stylized it should be, or it will appear too "real" and offend people. Rude TV shows need to have a tongue-in-cheek quality. Most importantly, the rudest shows are a combination of naughtiness and innocence; the innocence offsets the bad manners. This is why most rude shows feature friendly animals or babies. It takes the sting out of the otherwise offensive gags.

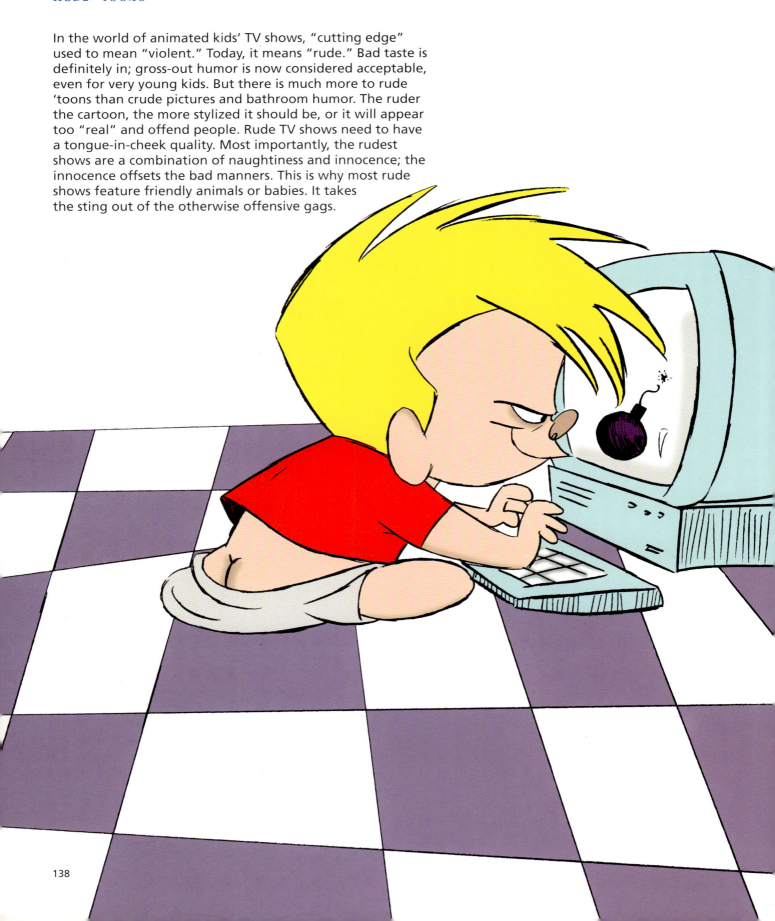

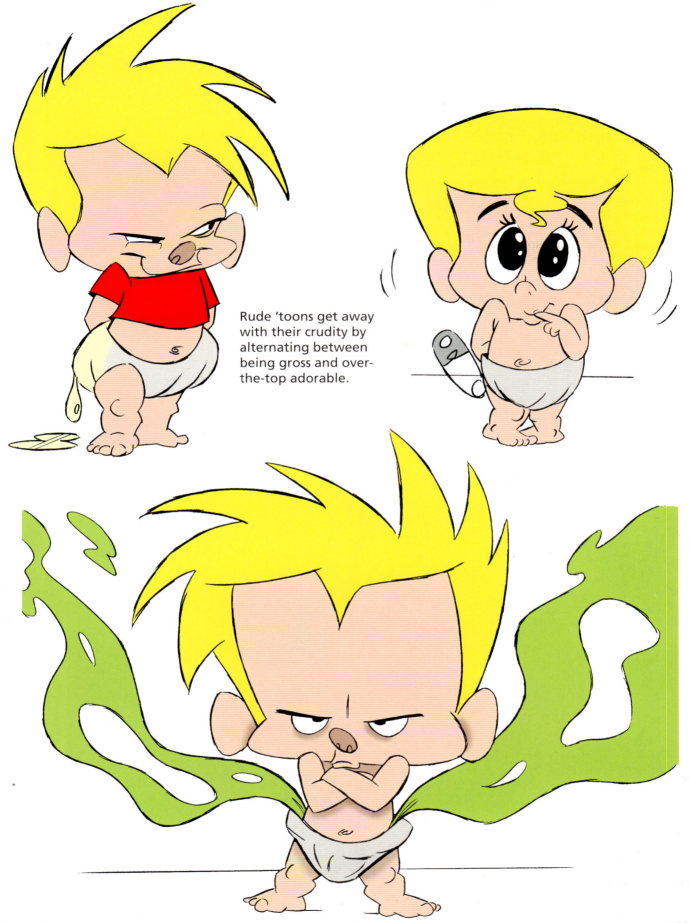

Rude 'toons get away with their crudity by alternating between being gross and over-the-top adorable.

Frequently Asked Questions

ABOUT CARTOONING, ART SCHOOLS, AND CAREERS IN ART

In my appearances at book conventions, art demos, schools, and book signings, I've learned a great deal about what cartooning issues are on people's minds. I also receive many letters from aspiring cartoonists asking for advice. It finally occurred to me that I could be most helpful if I dedicated a section of one of my books to the most common questions, and provided answers to them. My responses are based on my own personal experiences as well as what I've learned from working with some of the finest artists in the field. While my advice may not necessarily be right for your particular case, I hope you find it useful in some way.

WHAT IF I CAN'T DRAW A STRAIGHT LINE?

That's what they invented rulers for! Every cartoonist has rulers and templates for drawing circles, squares, and all sorts of shapes. Cartoons are rarely based on straight lines, anyway. They are round and rubbery. Drawing is not a motor skill, like playing tennis. It's about communicating an idea. Some cartoonists can communicate ideas in a wonderful and humorous way without a great degree of artistic detail, as in the popular comic strip *Dilbert*. Others feel that more elaborate art is required for their subject matter. Try to be true to your subject matter rather than keeping a predetermined idea of the way you feel you must draw. Your style will unfold as a natural part of your artistic development. Don't try to impose one on yourself at the beginning.

DO I NEED TO GO TO ART SCHOOL TO BE A CARTOONIST?

The short answer is no. In all fields of cartooning, there have been innumerable self-taught artists who have gone on to become highly successful. Comic strips require the least formal instruction. Some animation studios require it, but many don't. Comic book publishers require you to be capable of drawing a detailed human body, but if you can do it without formal training, that's fine with them. They are only interested in the work, not your background.

WHICH ART SCHOOLS DO YOU RECOMMEND?

It all depends. Are you doing this as a hobby? Then I would recommend just practicing. If you are serious about taking your talent further, and you want to go to an art school, it can only help. I would recommend any highly respected art school in your area, but not a university. Universities and liberal arts colleges are notorious for having terribly inferior art departments. In my opinion, you would learn more in one year at a mediocre art school than in four years at a liberal arts college.

My top picks would be the California Institute of the Arts (Valencia, CA), especially for those interested in animation; Sheridan College (Ontario, Canada); and the Ringling School of Art and Design (Sarasota, FL). But don't go to Sheridan if you live in the States. Canadian schools are always bragging that they teach Hollywood-style animation. So why would you want to go there to learn a technique developed here? In addition, it will be tougher to network in the United States when your clique is from a foreign country.

I would also recommend Pratt Institute(Brooklyn, New York) for animation as well as commercial and fine art. New York University, in New York City,

might be worth a look, as it is very well funded and has a highly regarded film school; but it has been my impression that for those interested in drawing, it is sub-par. Parsons School of Design, also in New York, is reported to be excellent for illustration, as is Art Center in Pasadena, California.

It's a good idea to ask the schools for a list of their alumni who have done well in cartooning or animation. If the list seems impressive, that's a good sign.

HOW DO I GET INTO A GREAT ART SCHOOL?

This is what you do: call for the application *one year before* you're ready to apply. Visit or speak to the head of the art department. Visit the school and look at the students' work, and preferably, sit in on a class or two, if only for a few minutes. Most schools offer a tour.

Find out *exactly* what they want to see in your portfolio. Then spend the next year creating exactly that, making a fabulous portfolio, tailored for them. If they want to see life drawings, take life drawing classes. If they want to see still lifes, draw or paint still life. If they want to see cartoons, create cartoons. This is a much better approach than just "giving them what you've got," or rushing to come up with something a month before applying. Art schools will not care a great deal about your grades. They want to see your work.

WHAT IF THERE IS NO ART SCHOOL NEARBY?

In that case, you may have to enroll in a continuing educational course at a university. Many towns also have publicly funded art centers. You may have to drive further for what you want. If neither of those options is available, continue to learn from books. Many successful artists are self-taught. And all formally trained artists that I know supplement their education with books on art technique, like this one.

WHAT CAREER OPTIONS ARE AVAILABLE FOR CARTOONISTS?

Cartoonists have a wide range of career possibilities. There's advertising, animation, computer graphics (and multi-media), comic strips, comic books, children's book illustration, art directing, toy design, electronic game design, amusement park design, humorous illustration (magazine cartoons) and greeting cards, to name a few.

DO CARTOONISTS MAKE A GOOD LIVING?

Some make a fabulous living. Every field has its stars, and there is no shortage of them in cartooning. Of course, it all depends on talent, perseverance, and timing.

HAVE YOU WRITTEN ANY OTHER BOOKS FOR BEGINNING OR INTERMEDIATE CARTOONISTS?

For those interested in pursuing a career in comic strips who want to learn how to sell their work and exactly where to submit it, I would recommend my book *Drawing on the Funny Side of the Brain,* published by Watson-Guptill Publications. It also features an exclusive interview with a prominent New York intellectual property rights attorney who instructs you on exactly how to protect your work.

For those who want to go further in animation, I would recommend *How to Draw Animation,* also published by Watson-Guptill. It is both instructive and visually inspiring, with many examples of sequential animation and character design. It also features an exclusive interview with Roger Allers, director of Disney's most successful animated film of all time, *The Lion King,* in which he offers his advice for aspiring animators who are looking to get into the business.

I have written many other books, which you can find in your local bookstore's "art technique" section, or by looking me up on any major bookstore website.

I HAVE TROUBLE DRAWING CERTAIN PARTS OF THE BODY. WHAT SHOULD I DO?

Keep trying to draw what you're having trouble with. Don't shy away from it; tackle it! But there is one caveat: tackle one thing at a time. If you have trouble drawing hands and feet, then decide that from now on, you won't shy away from drawing feet. But don't tackle the hands problem at the same time. You don't want to overwhelm yourself. This should be fun, not a chore.

WHAT KINDS OF MATERIALS SHOULD I USE TO DRAW, OR TO SET UP MY STUDIO?

It's best to go to a big art store with a prepared list and ask the salesperson for help. Describe what you want to do. This is their business, and they're good at it. No matter what you're asking for, they've heard your request before. A good salesperson will be able to direct you and give you many choices.

THANKS FOR VISITING! AND REMEMBER—

KEEP DRAWING!

BEST OF LUCK TO YOU!